natural

contrast

ure

harmonious

subtle

classic

inspiration

success

n do it . . . **B&Q**

MA

D0236814

Understanding
Colour
at home

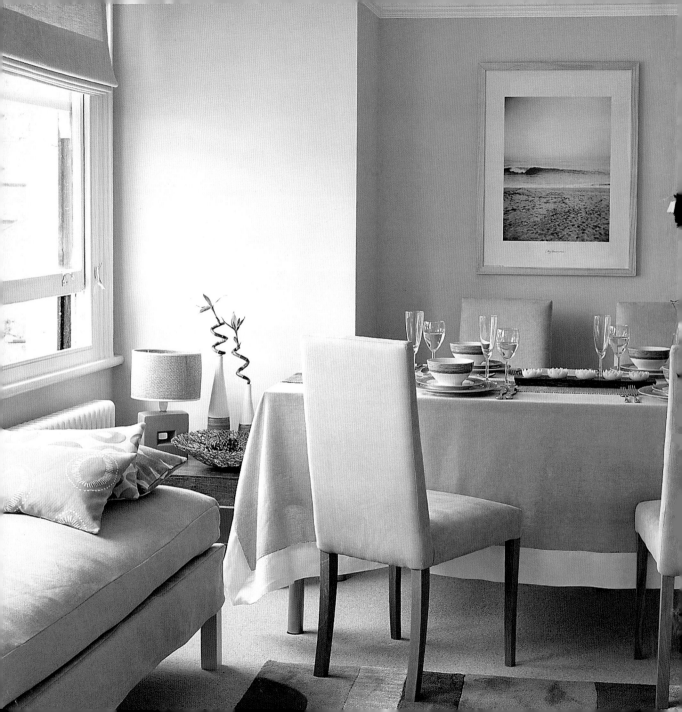

Understanding
Colour
at home

With over 280 colour illustrations

0061156230

 Thames & Hudson

AB	MM
MA ⌐65	MN
MB	MO
MC	MR
MD	MT
ME	MW
MG	
MH	

What's your favourite colour ?

That used to be a simple question with a single answer...but life's become so much more interesting. Expressing our dreams and desires requires a spectrum of colours.

That's why I'm proud to introduce *Understanding Colour at Home*, a new book from B&Q offering all the know-how and inspiration we need to create stylish and individual homes.

Understanding Colour at Home builds confidence through knowledge. It includes everything from scientific insights, like the power of colour to affect our moods, to important decorating principles, like how colour can alter the proportions of a room.

As with our first bestselling book, *You Can Do It – The Complete B&Q Step-By-Step Book of Home Improvement*, *Understanding Colour at Home* was developed by a collaboration of experts from B&Q and Thames & Hudson, the world leader in illustrated books.

Understanding Colour at Home reflects B&Q's unwavering promise to keep home improvement affordable and to help you make your home better in every way.

As well, it enriches our partnership: we supply the colour and know-how; you provide the imagination. The possibilities are exciting and endless.

Enjoy!

B&Q

David Roth Marketing Director, B&Q

contents

colour for life 8

colour with confidence 26

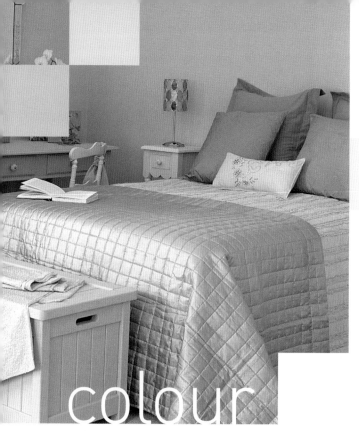

colour
at home 116

colour
the senses 70

colour
for life

Colour has the power to transform our homes – not just the way they look, but the way they feel and the way we live in them. It can stimulate or soothe, energise or pacify. It can even give you a headache.

It doesn't have to. With this book, B&Q shows you both the magic of colour and how to make it work for you.

Colour is around us all the time – of course we take it for granted. We'd never get anything done if we didn't. But for once here is a case where a little knowledge can create a lot of inspiration. Because when you begin to take a closer look, the familiar phenomenon of colour turns out to be a subject full of surprise and wonder.

How many colours are there in the rainbow?
We're taught at school that there are seven: red,
orange, yellow, green, blue, indigo and violet.
In fact it's all in the eye of the beholder.

colours of the
rainbow

Sir Isaac Newton was the first to identify this colour spectrum in 1666 while playing with glass prisms in his bedroom (he had been sent home from Cambridge University because of an outbreak of plague). He originally saw just five colours, but added two more, indigo and orange, because along with his contemporaries he believed that seven was a cosmically significant number – there being seven notes in a musical scale, seven days of Creation and seven days in a week. In reality, the colours of the rainbow merge gradually into one another – it's our eyes that sort them into groups.

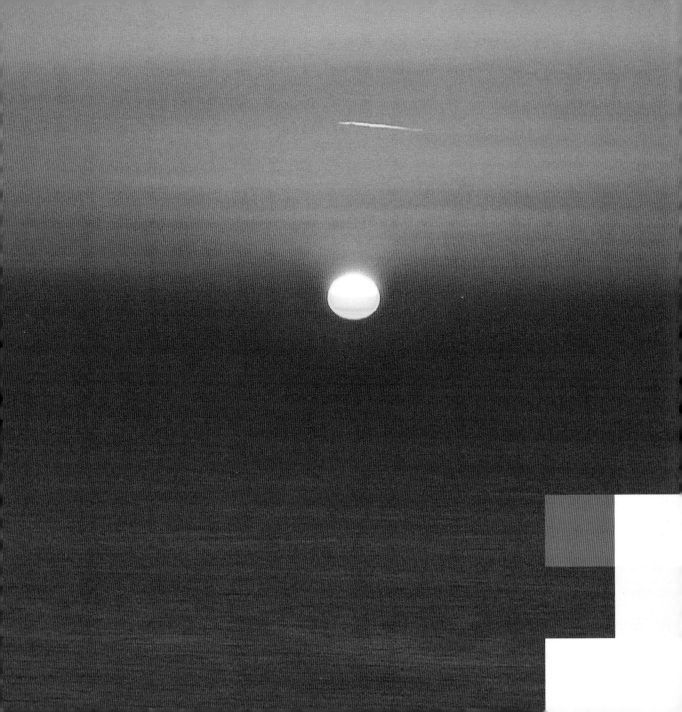

red sky at night

Sunlight is actually white, a 'colour' made up of all the colours of the rainbow. But as it journeys from the sun to the earth, its different wavelengths become separated. The blue part of the light, with the shortest wavelength, gets thrown off course and scattered by particles in the atmosphere: that's why the sky looks blue to us in daytime.

At dusk and dawn, when sunlight has further to travel through our atmosphere, even less of the blue light reaches us, making the sky turn shades of red, pink and orange. Ironically, one of the effects of air pollution is more vivid sunsets: small particles of dust and gas trap more blue light, so the other colours appear deeper.

Colour is light of different wavelengths, processed by the human eye and brain. Our eyes can see over a million different colours. Even so, some animals can see parts of the spectrum that we can't.

humans, birds and bees

Honeybees' favourite colour is ultraviolet, invisible to us humans. On the other hand, bees cannot see red. When they are attracted to corn poppies, it is because the flowers reflect ultraviolet light – not because of the brilliant scarlet colour we see. Most mammals apart from apes see largely in black and white, but insects, fish and birds have all adapted to have some colour vision.

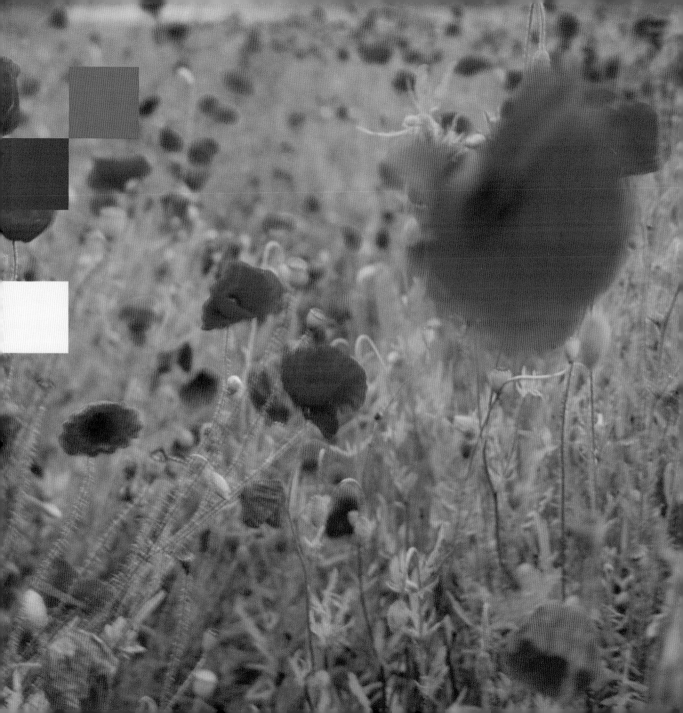

The term colour blind is misleading. It doesn't mean seeing the world in black and white, which is almost unheard of in humans.

colour blindness

People who are colour blind do see colour; what they can't do is tell the difference between pairs of colours, most often red and green, more rarely blue and yellow. But there are compensations. Colour-blind people tend to have exceptional night vision. They may also be instinctively more sensitive to contour and outline. In World War II, colour-blind soldiers were taken up in spy planes because they could spot camouflaged enemy camps that were invisible to people with normal sight.

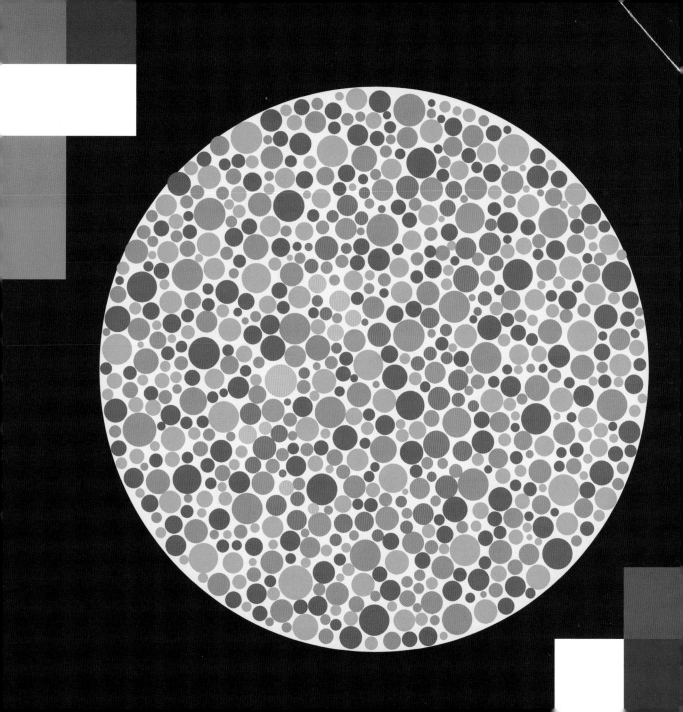

Colour and taste are powerfully linked. In the USA, scientists invited two hundred women to judge the flavour of coffee served from brown, red, blue and yellow coffee pots. The results were surprising: coffee from the brown pot was found to be too strong; the red pot rich and full-bodied; the blue pot mild but pleasant; and the yellow pot too weak. In fact it was exactly the same coffee in all of them.

the flavour of colour

Children love eating colourful foods, though adults aren't usually quite so keen. Bright blue can be particularly unappetising, as there are very few naturally blue foods. But when blue Smarties were introduced in 1989 as part a promotion, they were so popular that they were added permanently, replacing the old light brown Smartie.

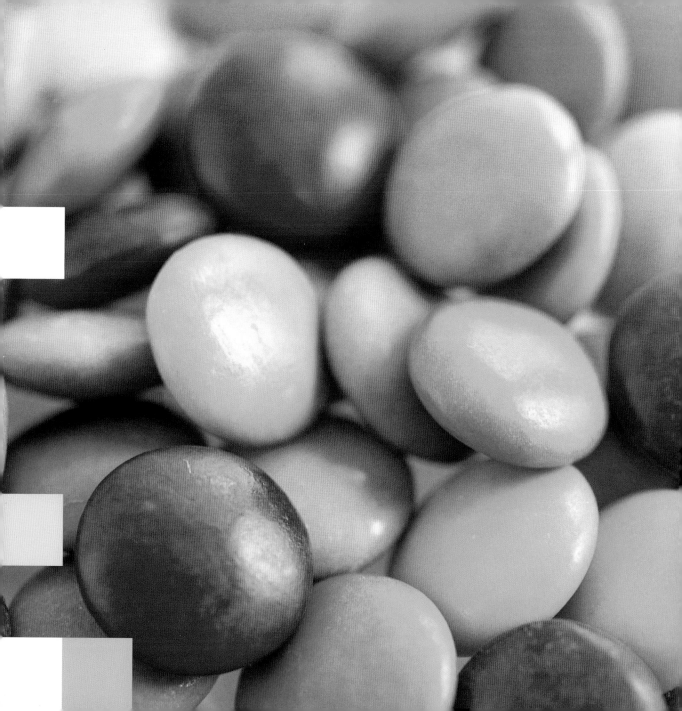

Desert sands are made up of quartz crystals that include iron impurities, which over time oxidise and turn red, just like rusting metal.

ancient sands

You can tell the age of a desert by the colour of its sand: 'younger' deserts are yellow, while really ancient deserts – such as those on Mars – are red.

colour for life

Colour has a powerful impact on how we feel. Green, the colour of nature, is calming – that's why actors relax in a 'green room' before going on stage. Green can even help people recover from stress or illness: research shows that patients getting over surgery leave hospital sooner and need fewer painkillers if their room has a view of greenery.

healing powers

Bright shades of red and yellow, on the other hand, make us feel dynamic and positive, and are used in physiotherapy centres and gyms to promote feelings of energy and well-being. Chromotherapy – the use of colour for healing – is a fast-growing field of alternative medicine.

In India, vibrant colours play a big part in Hindu culture. Gods are associated with different primary colours: blue for Krishna, yellow for Vishnu and red for Lakshmi. On the annual festival of Holi, people sprinkle each other with 'gulal' or vividly coloured powder dyes.

colour and culture

Everybody parades the streets to the sound of drums, armed with buckets of gulal and sprayguns of coloured water. No one is spared. For the festival of Holi, everyone is equal. This is a time for people of every caste and social position to come together and forget past differences.

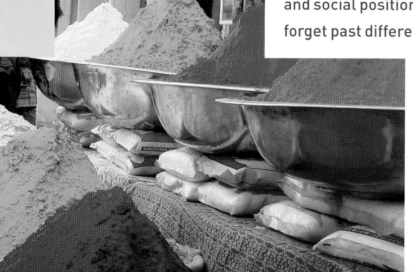

colour
with confidence

A little science goes a long way when it comes to colour. Professional designers use the colour wheel to show the relationships between different colours: which ones work together and which clash, which combinations are restful and which stimulating. It can give you confidence, too, to trust your instincts and realize your own visions with colour.

Different colours can affect our impressions of space, making a small room seem bigger or a big room cosier. Colour also changes with the light from morning to evening, and under different types of artificial light. Once you understand these effects, they become tricks to be used to your advantage.

Because when you know how to use it, colour really can make an ordinary home extraordinary.

27

Colour is not only an art, it is a science. Artists
and designers have spent centuries studying the
relationships between the different colours
of the spectrum. Now let them help you.

combining
colours

Our eyes can play tricks on our brains when we
look at two or more colours together. That's
why when planning an interior it's so important
to think of colours in combination rather than
isolation; it's also why the colour wheel is such
a helpful tool.

The colour wheel shows the relationships
between the colours of the spectrum. At equal
spaces around it are the primary colours – red,
blue and yellow. Halfway between them are the
secondary colours – green, orange and violet
(purple). Between the primary and secondary
colours are the tertiary colours.

Those are the twelve colours of a traditional
colour wheel. But it is possible to go on mixing
colours to produce wheels with 24, 48 or more
variations; each time the difference between
adjacent colours becomes more subtle.

**Colours can look quite
different in combination.
The blue bars below are all
exactly the same shade, but
surrounded by white they
appear distinctly lighter.**

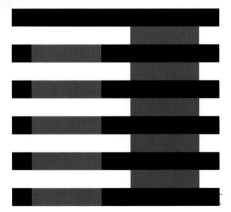

colour with confidence

Each central square here is the same size and colour, though our eyes seem to tell us otherwise.

Primary colours – red, yellow and blue – are the only ones that can't be made from mixtures of other colours

Secondary colours are made from mixing equal amounts of the two nearest primary colours

Tertiary colours are made from a primary colour mixed with a small amount of a second primary

Certain combinations of contrasting colours can seem to vibrate before our very eyes. It's almost impossible to focus on the point where they meet.

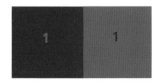

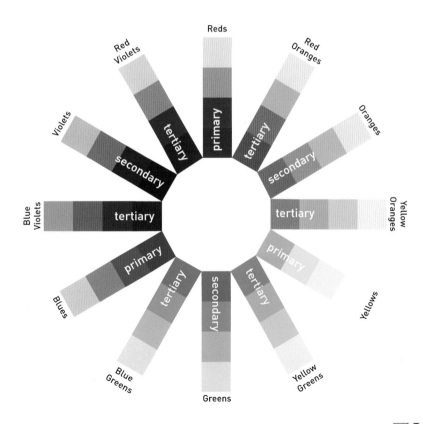

contrasting

harmonious

Harmonious colours sit next to or close to each other on the colour wheel.

Contrasting colours sit opposite each other on the colour wheel. Designers also call them complementary colours.

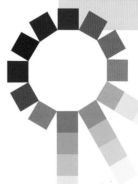

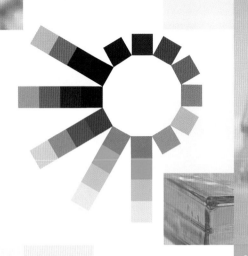

Cool colours lie on the
blue side of the wheel.

warm

Warm colours lie on the
orange side of the wheel.

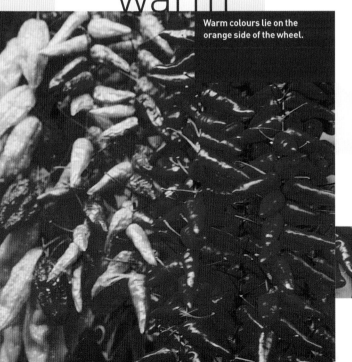

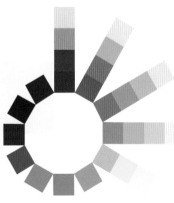

Some important colours are missing from the colour wheel: black, white and neutrals – shades of grey, cream, beige and brown. These are all essential ingredients in any designer's palette.

neutrals

Are black and white 'true' colours? Even the experts don't agree on the answer to that. But there is no denying that side by side they are the most classic of all the contrasting colour partnerships. Grey – perfectly poised between black and white – is generally considered the 'truest' neutral because it neither emphasises nor diminishes the qualities of other colours around it. But the sliding scale between black and white holds an infinite array of shades, from chalk white, bone white, magnolia and buttermilk through silver, slate, charcoal and granite.

colour with **confidence**

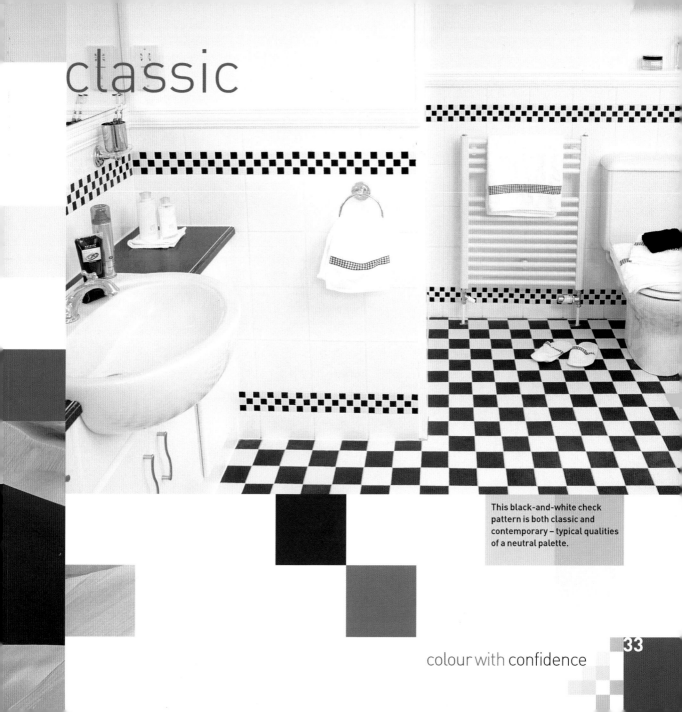

classic

This black-and-white check pattern is both classic and contemporary – typical qualities of a neutral palette.

colour with confidence

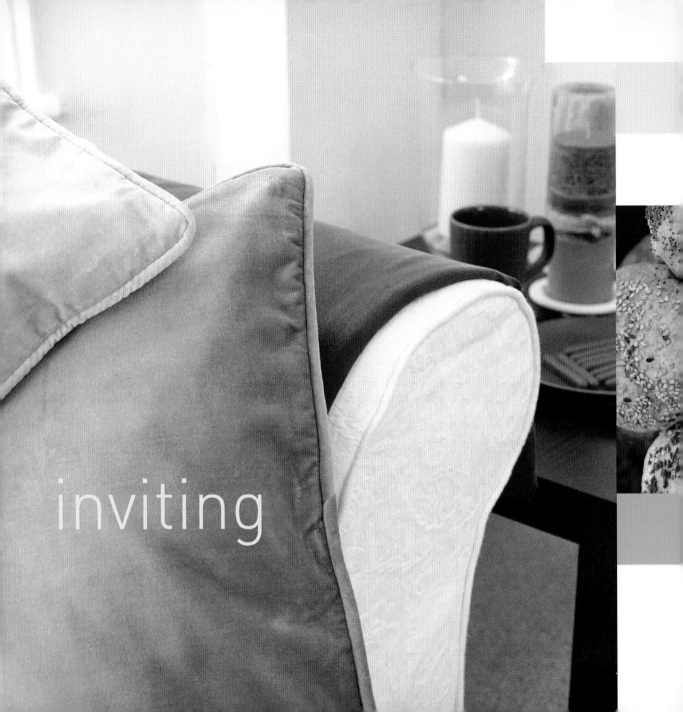

inviting

vibrant

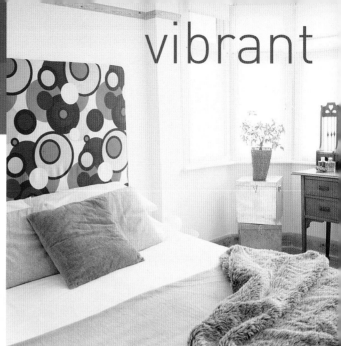

Chocolate, coffee and freshly baked bread: this palette of warm browns (left) has a comforting, nurturing quality that is enhanced by the inviting texture of velvet.

Grey merges subtly into beige and brown in the neutral palette. Many shades of brown are derived from orange: think bright tans, autumn leaves or warm russets. Other neutrals are complex mixes of many colours. Dark browns range from virtually black to almost grey, while light browns can be beige as well as deliciously rich cream, honey, caramel and milk chocolate.

Whether used on their own to create a sophisticated contemporary look, or as an antidote to bold colour, neutrals are not to be overlooked. They play a part in practically every colour scheme.

Any colour can be made lighter, darker or more muted by adding white, black or grey. The variations are infinite.

one colour
many variations

It's perfectly possible to design a successful interior based on a single colour. This is a monochrome scheme. The way to prevent monochrome becoming monotonous is to work with lighter, whiter tints and deeper, darker shades, as well as introducing a range of different textures. Interior designers call the dulling or darkening of colours 'knocking back' – and the results can be wonderfully subtle.

Different shades of colour are also useful for creating illusions and effects: you can deliberately draw the eye to a particular feature in a room – a radiator, for example – by painting it a slightly paler shade than the wall behind. This will make it appear more prominent. For the reverse effect, paint the radiator exactly the same shade as the wall – it will seem to fade into the background.

colour with confidence

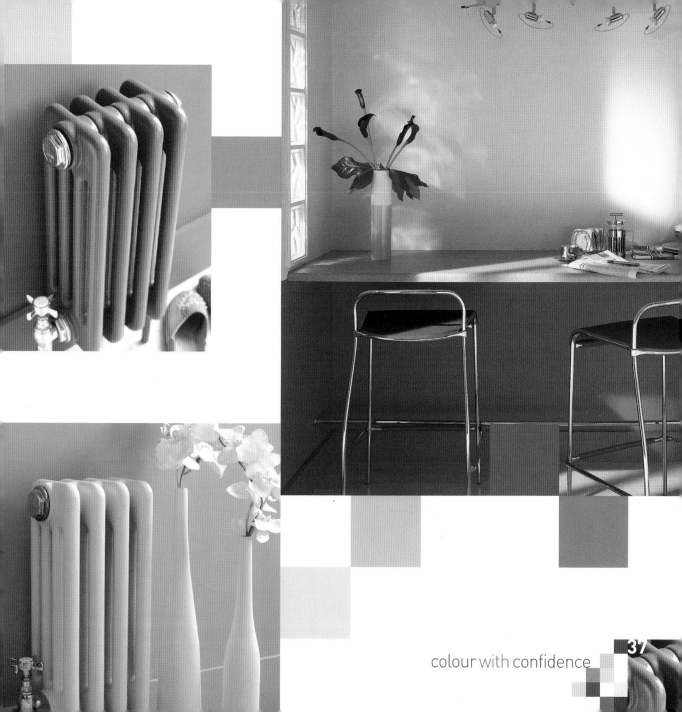

colour with confidence

relaxed

Combinations of harmonious colours are restful on the eye, even vivid reds and pinks. This is because they are created from very similar mixtures of colours.

colour with confidence

Harmonious colours sit next to one another on the colour wheel. Because they are closely related, they combine easily, creating a calm and relaxed effect.

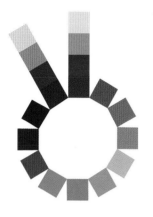

harmonious
colours

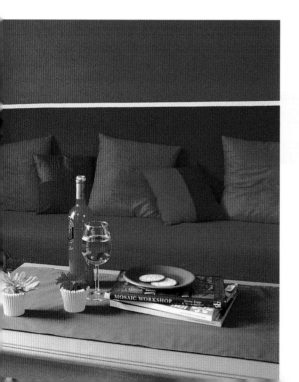

A simple but highly effective way of devising an interesting colour scheme is to use two or three harmonious colours. Because they are closely related, harmonious colours look easy and natural together – none is 'singing out of tune'. This principle can throw up some unexpected combinations: red and orange, lime and turquoise, red and pink. Keep to colours of similar shades to avoid any one being upstaged. If one of the colours in your palette is a primary, the result will have more impact. But even vivid colours can feel surprisingly restful when combined in this way.

Contrasting or complementary colours sit opposite one another on the colour wheel. Because they are totally unrelated, put them together and the effect is vibrant.

contrasting
colours

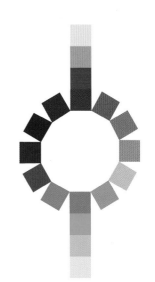

Where a harmonious scheme uses two or three related colours to produce a calm effect, a scheme made out of contrasting colours can be truly dramatic.

Nature throws startling colours together all the time, and they look fabulous. Even so, it can be hard to live with vividly contrasting colours used in equal amounts in a room. One solution is to tone down one or both of the colours by choosing subtler shades rather than the most brilliant. Introducing areas of white or a neutral will also help balance a contrasting scheme.

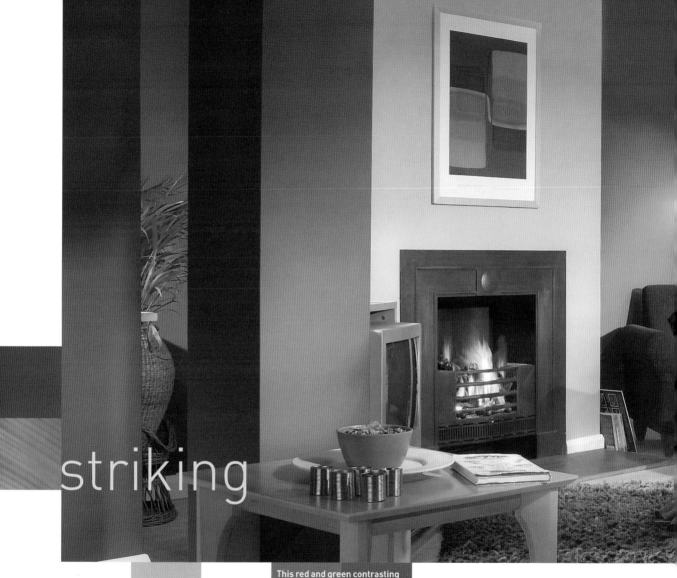

striking

This red and green contrasting colour scheme uses muted shades of dusky red and pale pea green: much easier to live with than scarlet and emerald.

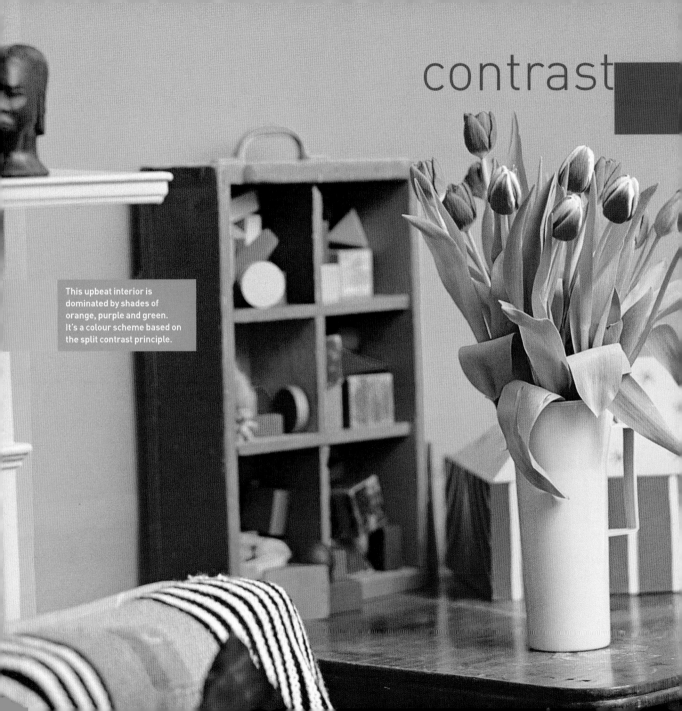

contrast

This upbeat interior is
dominated by shades of
orange, purple and green.
It's a colour scheme based on
the split contrast principle.

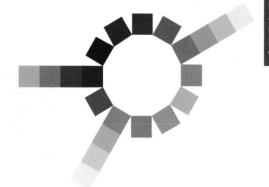

Introducing white or a neutral to a contrasting scheme will make it feel more open and balanced. Bold colour contrasts work well with funky modern furnishings.

balance

Another kind of contrasting colour scheme is the split contrast. This combines three colours – two closely related and one completely unrelated – to create a bold and lively look.

The playful colours of this living room (left), make a really individual statement. Instead of a pair of opposites on the colour wheel, a split contrast replaces one of the pair with the colours either side of it to make a three-way scheme.

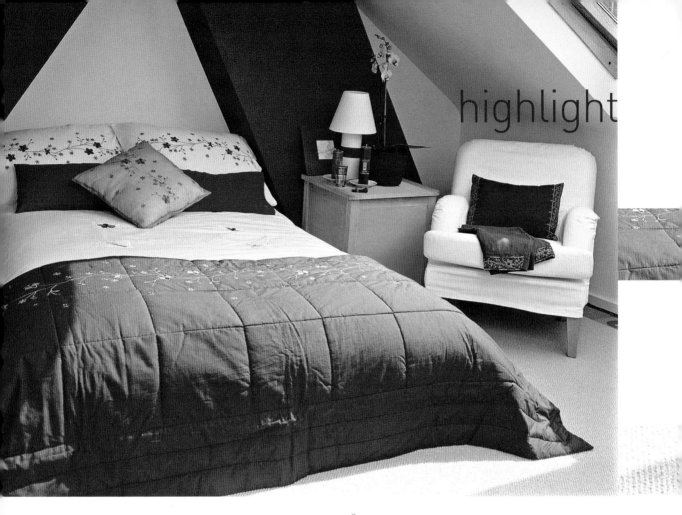

highlight

accent colours

Detail colours, or accents, are all about contrast: light against dark, cool colours against warm, strong colours against weaker ones.

Accents are a great way of livening up both harmonious and single-colour schemes. They can also be a way to work with contrasting colours: one becomes the base colour and its opposite the accent. An accent colour might be introduced through textiles, accessories, rugs or wall hangings. Use it more than once, in different parts of the room, and it will draw the eye around the space and make your colour scheme 'hang together'.

A very stylish use of accent colours is against white. This can be an excellent way to introduce a brilliant colour that on its own might be overwhelming and much too dark for the setting.

An accent colour can also be used to transform a mundane object – a radiator or exposed pipework – into a dynamic design feature. Accents have the added advantage of being very easy to change: switch accessories, repaint shelves and radiator, and you suddenly have a whole new colour scheme.

An accent is a highlight colour, used in small amounts here and there to give a 'lift' to an interior. In this bedroom the accent is hot magenta; the base colours are white and creamy beige.

colour with confidence 45

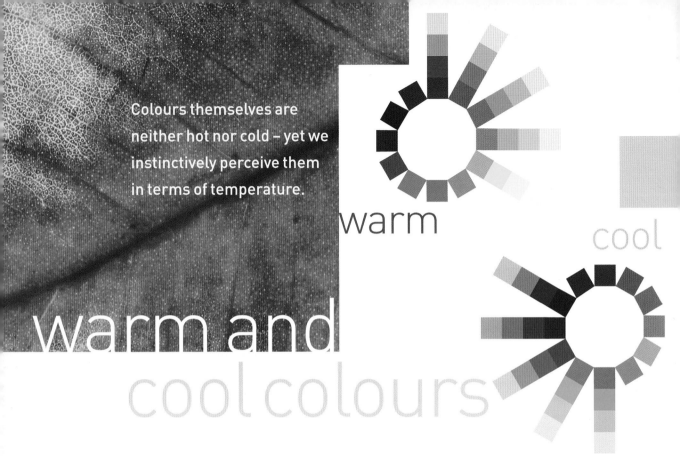

Colours themselves are neither hot nor cold – yet we instinctively perceive them in terms of temperature.

warm

cool

warm and
cool colours

On one side of the colour wheel are the warm colours – red, orange, yellow – the colours of fire and the sun. On the other are green, blue, purple – colours we relate to ice, oceans and cool, fresh foliage. These are powerful associations. Scientists in Norway found that people in a blue room turned the heating thermostat several degrees higher than those in an identical red room: proof that colour really can alter the way we feel in an interior.

You can turn these effects to your advantage. Different colours will warm up or cool down the mood of a room to suit its use or position. Even with big windows, a north-facing room can seem gloomy and dull, and cool colours will only add to the chill. But warm colours, with their enveloping, cosy quality, will help compensate for it. In a bright, light space, on the other hand, cool colours feel restful and airy.

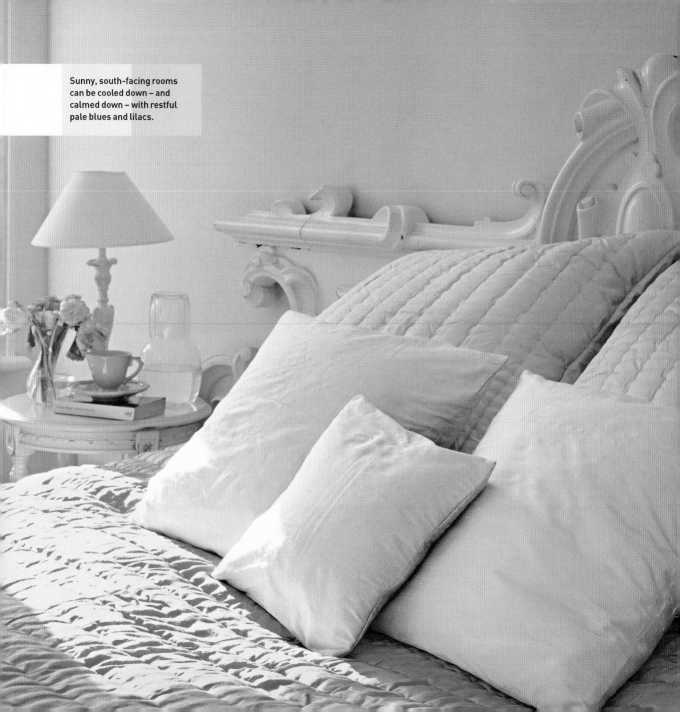

Sunny, south-facing rooms
can be cooled down – and
calmed down – with restful
pale blues and lilacs.

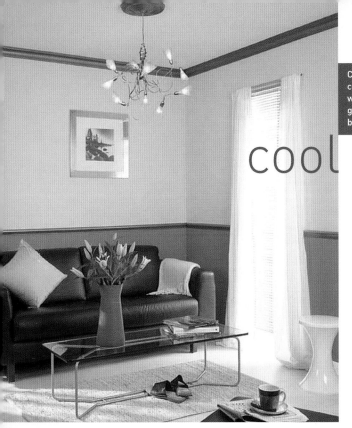

cool

Neutrals can also be warm or cool: the creamy shades of beige, honey, coffee and chocolate brown are rich and warm, while bright whites, stone, slate and graphite greys are elegantly cool.

colour with confidence

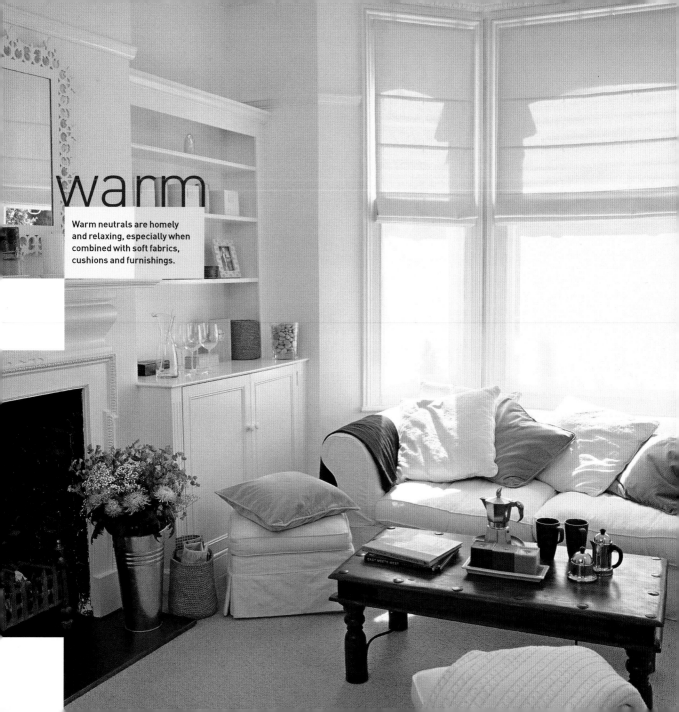

warm

Warm neutrals are homely and relaxing, especially when combined with soft fabrics, cushions and furnishings.

Warm and cool colours don't only create atmosphere; they also influence the way we perceive distance. Warm and dark colours are advancing: the eye sees them as closer. Cool and pale colours are receding: the eye sees them as further away.

advancing
and receding colours

Colour can play tricks with our sense of distance. If you were to put a white chair and a dark red chair side by side and then walk to the opposite end of a long room, it really would look like the red chair was nearer to you. In the same way, different colours can seem to either push wall surfaces away, or draw them towards you.

This makes colour a great tool for disguising awkward proportions. In a tall, narrow hallway, for example, you might paint the walls a pale shade: white is the ultimate space-making colour, though pale blues come a close second. For the floor and ceiling you would choose a darker, warmer colour to reduce the height of the space.

But maybe you want to use a rich warm colour without significantly altering the sense of scale. The answer is to balance it with much paler areas like the lower wall and floor (right), which preserve a sense of openness and space at ground level.

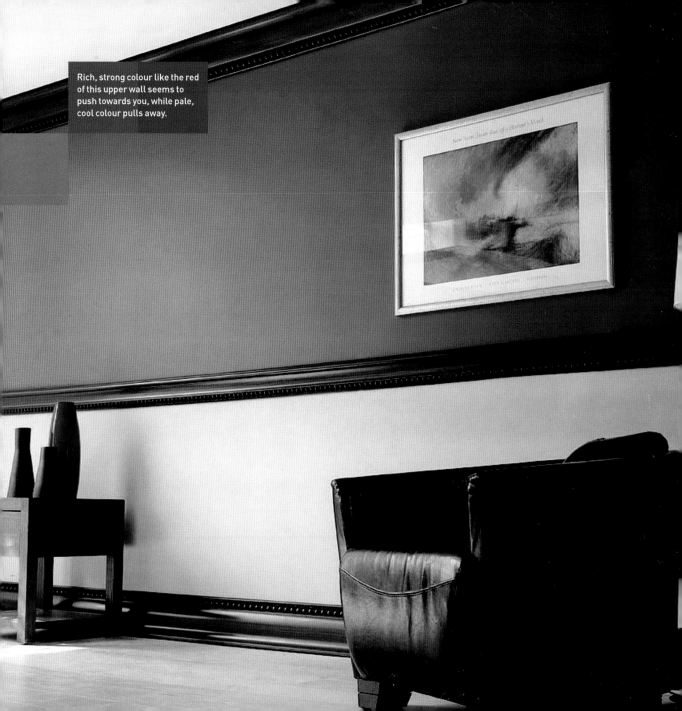

Rich, strong colour like the red of this upper wall seems to push towards you, while pale, cool colour pulls away.

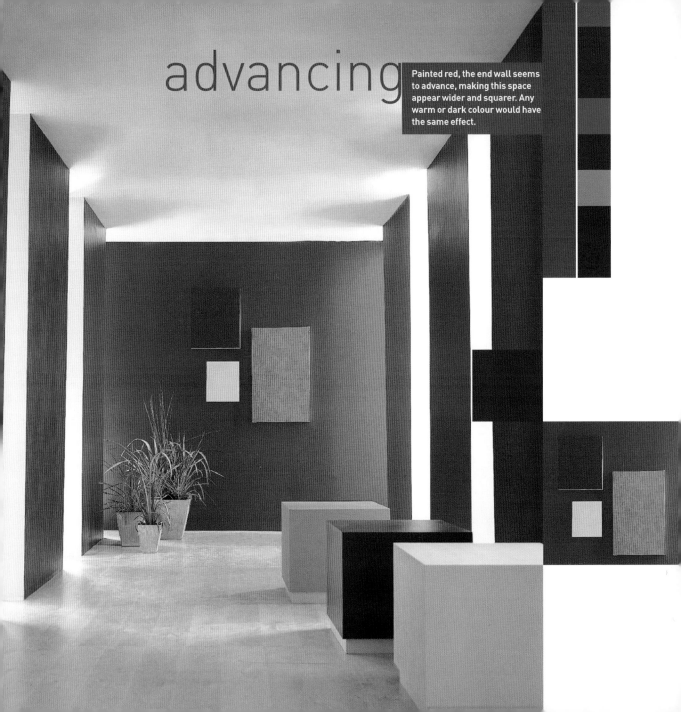

advancing

Painted red, the end wall seems to advance, making this space appear wider and squarer. Any warm or dark colour would have the same effect.

Dark or warm colours make surfaces seem closer. White or pale colours appear to push them away.

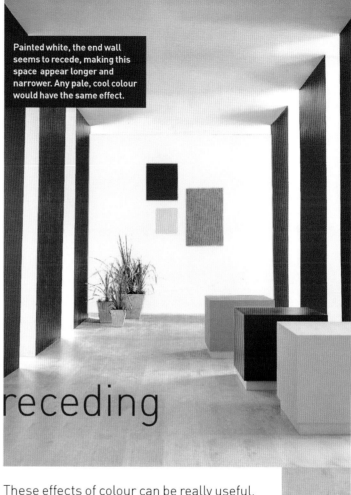

Painted white, the end wall seems to recede, making this space appear longer and narrower. Any pale, cool colour would have the same effect.

Against white, the darkest panel stands out most strongly. Against red it's the reverse: the palest is most prominent. The panels are identical, but the pattern they form looks completely different.

receding

These effects of colour can be really useful. In a long, narrow room, for example, the proportions can be downplayed by applying an advancing colour to one or both of the end walls. Or you could bring forward a window wall by choosing curtains in an advancing colour.

The quality and intensity of daylight varies from room to room in any house, and also changes subtly throughout the day and year.

colour
and light

When we choose colours, we often make judgements based on looking at them under sunlight or shop lights. This isn't always wise. Colour can change significantly depending on the light you view it in.

South-facing rooms receive direct sunlight for most of the day. Because of that, their light has a warm look. Under it, cool colours appear crisp and fresh, and strong colours vivid and bright.

It's easier to go wrong with colour in rooms that receive only indirect sunlight for all or most of the day. Indirect light, especially in rooms facing north, is less intense and bluer. It has a cooler feel,

colour with **confidence**

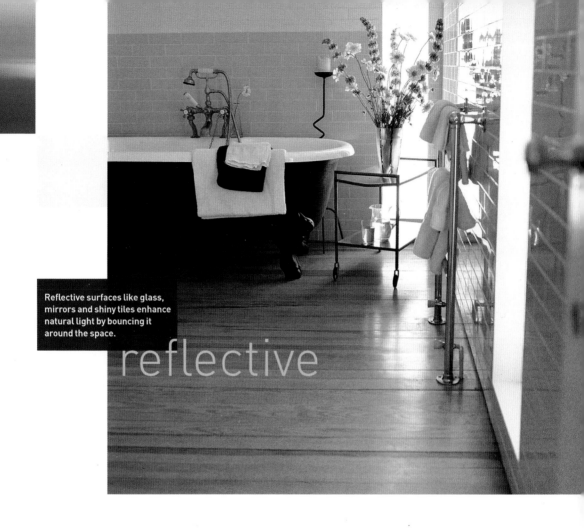

Reflective surfaces like glass, mirrors and shiny tiles enhance natural light by bouncing it around the space.

reflective

even in summertime. It is more even and doesn't cast strong beams or shadows: that is why artists traditionally prefer to work in a north-facing studio. However, its cool quality can make cool colour feel positively frosty, while strong and dark colours – which absorb a high proportion of light – can create a gloomy and depressing atmosphere. The solution is to opt for soft, pale tints of warm colours or neutrals that will reflect light back into the room and make it feel cosy and inviting.

colour with **confidence**

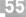

artificial
light

The standard light bulb – the tungsten filament – produces a light that is close to daylight, but a little more yellow. It adds a warm golden glow to white, cream or neutral-beige rooms, but can dull crisp, cool colours like green and blue. Fluorescent light, on the other hand, is more blue-tinged and so tends to make colours appear cooler. It also reduces shadows and flattens texture. Even so, it remains very practical in places where you need plenty of light to see by, and you can now buy 'warmer' fluorescent tubes that give off a whiter light.

Alternatives to these are daylight bulbs, which are closer to natural light; energy-saving bulbs, which create an even, soft, white light; and halogen bulbs, which produce a crisp white light that is excellent for spotlighting and highlighting particular features. You can buy bulbs in a range of colours too. In soft pastels, these can cast a warm glow over an area for eating or relaxing after dark. In bright colours they are great for parties or festive occasions.

Colour is also altered by different kinds of artificial light. The effect is slight but it can transform the mood of a room.

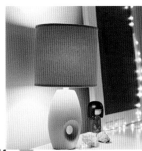

colour with confidence

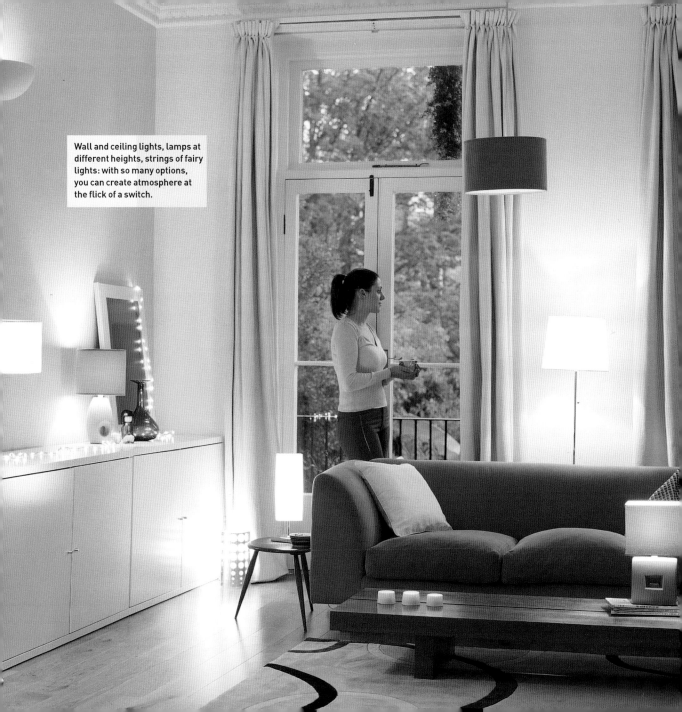

Wall and ceiling lights, lamps at
different heights, strings of fairy
lights: with so many options,
you can create atmosphere at
the flick of a switch.

Pattern and texture are two more exciting tools in the decorator's toolkit. Pattern can have as much impact as colour on the proportions of a space. And texture will really set the tone of an interior.

pattern and texture

Like colour, pattern can affect the apparent size of a room. That's because our eyes tend to move along the direction of a pattern: vertical stripes draw the eyes upwards and so on a wall they give the idea that the ceiling is higher than it actually is. In the same way, horizontal stripes can make a space seem wider. Chequerboard or diamond-shaped patterns on a floor can help make a small room appear larger, as it takes the eye a little longer to travel across them.

Areas of pattern, like colour, can be used to define zones or divisions in a space, or to create continuity from one area to another. A densely patterned wall will be 'relieved' by plain-coloured furniture placed against it, or by a plain ceiling or floor treatment. Or you might opt for boldly patterned upholstery against plain walls. The patterns themselves don't even have to match: a collection of prints, all harmonising with a common colour scheme, makes for a charmingly informal style

colour with confidence

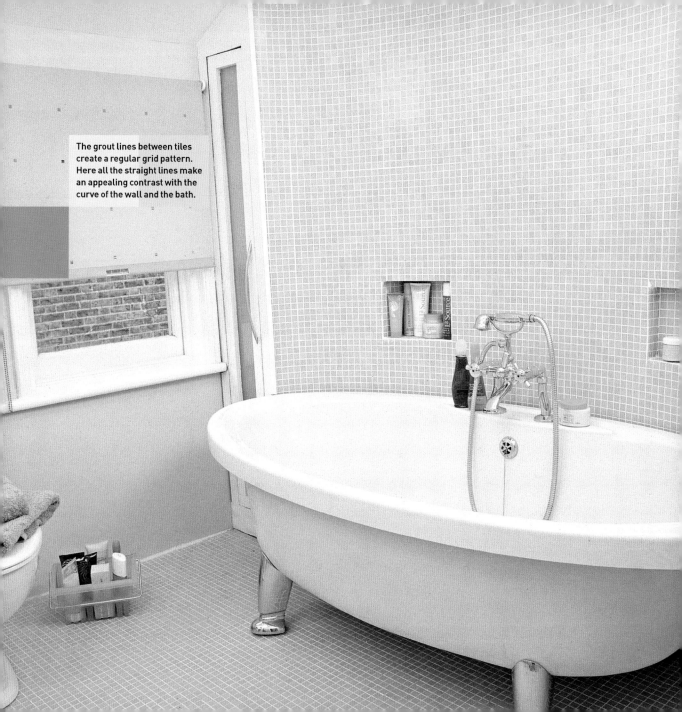

The grout lines between tiles create a regular grid pattern. Here all the straight lines make an appealing contrast with the curve of the wall and the bath.

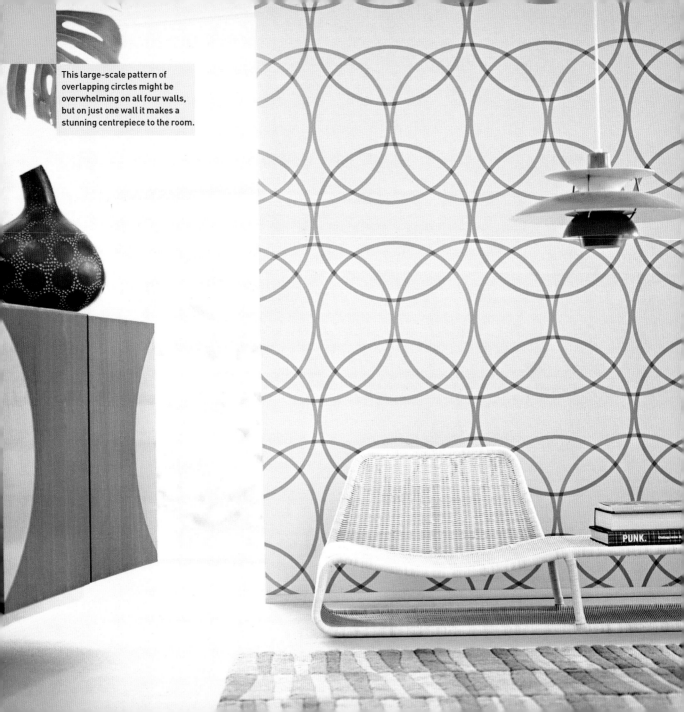

This large-scale pattern of overlapping circles might be overwhelming on all four walls, but on just one wall it makes a stunning centrepiece to the room.

Big pattern can make a big style statement. The trick to getting it right is to think about scale.

pattern

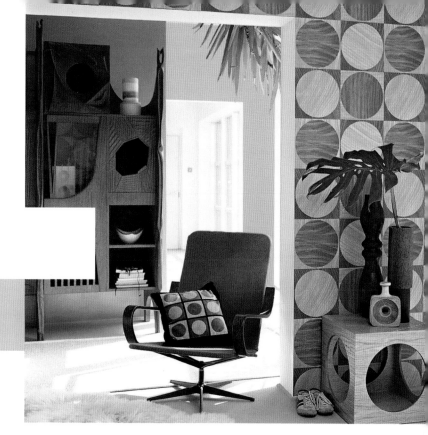

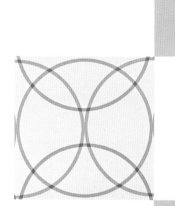

Covering all the walls of a room in a big or complicated pattern can make the space feel smaller, even claustrophobic. Use that same pattern in a more restricted way, however, and you can achieve quite the opposite effect. Being bold can really reap rewards: a large-scale, striking wallpaper pattern can be stunning when used on just one wall; or it can be featured at intervals around the room, for example on wall-mounted panels.

colour with confidence

The tactile qualities of a material –
its texture – are both real and
psychological: how it feels when you
touch it, and how you imagine it will
feel when you see it. Textures, like
colours, divide into cool and warm.

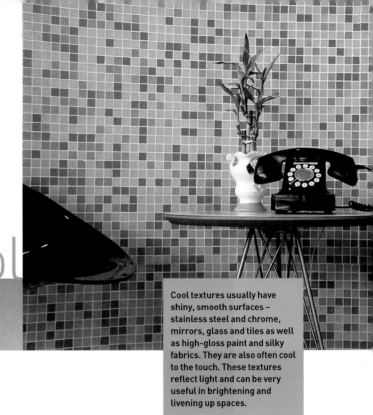

cool

Cool textures usually have
shiny, smooth surfaces –
stainless steel and chrome,
mirrors, glass and tiles as well
as high-gloss paint and silky
fabrics. They are also often cool
to the touch. These textures
reflect light and can be very
useful in brightening and
livening up spaces.

Textural contrasts alone can create visual interest in
a room: rough against smooth, or gloss against matt.
As with colour, the fall of light can enhance or reduce
the decorative effect of texture. Overall or direct light
flattens out textures, while soft pools of light cast
shadows that highlight them. So it's a good idea to
plan your lighting scheme with textures as well as
colours in mind, otherwise their subtlety could be lost.

warm

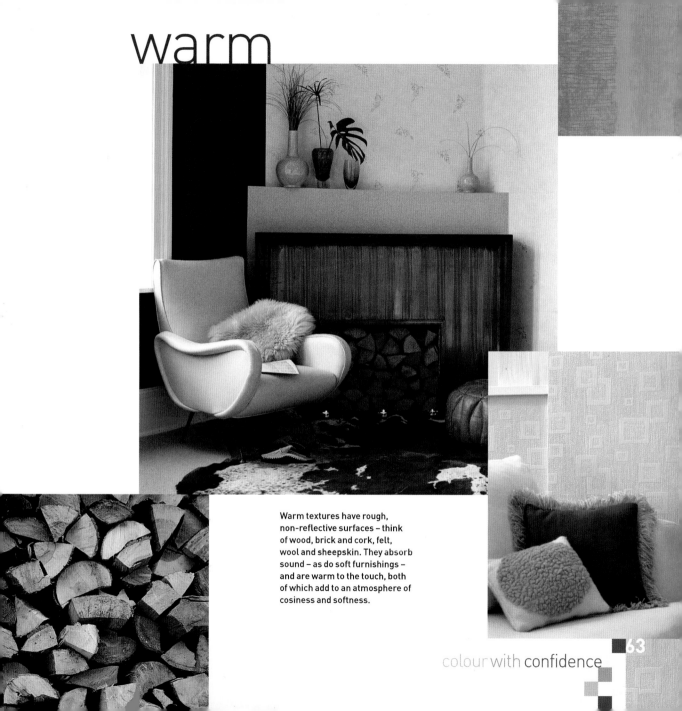

Warm textures have rough,
non-reflective surfaces – think
of wood, brick and cork, felt,
wool and sheepskin. They absorb
sound – as do soft furnishings –
and are warm to the touch, both
of which add to an atmosphere of
cosiness and softness.

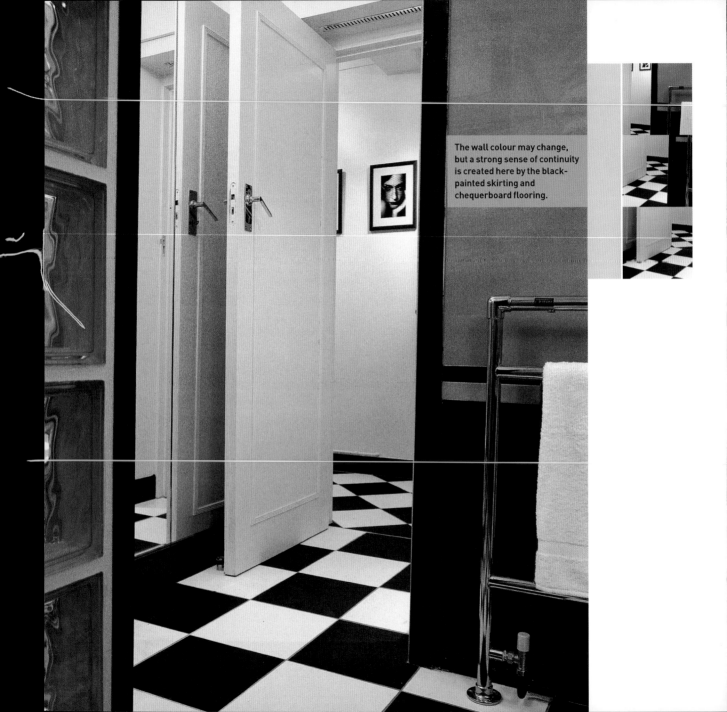

The wall colour may change, but a strong sense of continuity is created here by the black-painted skirting and chequerboard flooring.

Colour should ideally flow from room to room throughout a house: adjacent rooms can often be seen through open doors or archways, so their colour schemes need to coordinate rather than clash.

colour
from room to room

Redecorating a whole house – whether you have just moved in, or are simply ready for a complete change – is an opportunity to think on an entirely different scale. One approach is to choose two or three main colours, plus their tints and shades, as your core colour scheme. In addition you might have one or two accent colours, and perhaps an extra colour for trim details – mouldings, skirting boards, window and door frames. This will give you a palette just broad enough to create different moods and looks in every room – but you can still be sure that glimpses from one to the next will be easy on the eye.

But there are lots of other ways to create continuity from room to room. Keeping the same flooring – especially if it is patterned – may be more than enough to provide a visual connection between your different spaces.

Deciding on a colour scheme for a room can be both exciting and daunting; there are so many choices it's hard to know which way to turn. Creating a mood board is a great way to find what's right for you.

working
with a mood board

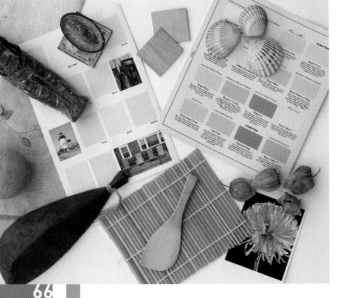

When thinking about a new decorative scheme, start by looking at real rooms that you like, and identify the colours, features and details that appeal the most. It may be the contrast of one colour against another, or simply that you feel relaxed in a particular room. Jot down your thoughts and feelings in a notebook: you can look back at them later to remind yourself of how you would like your own home to look and feel.

Ancient World Period	Georgian & Regency Period
Hemp Beige A natural colour of cloth made from hemp fibres, used throughout the ages in the creation of textiles such as rugs and tapestries.	**Regency Cream** A popular dark cream widely used in furnishing and wall decoration during the early 1800's. The Regency period took its name from the Prince Regent, later King George IV.
Ming Period	Arts & Crafts Movement
Deep Sung Cream The colour found in early Sung porcelain. The Sung dynasty brought China to one of its highest points in history artistically.	**Pale Oak** A favourite background colour of the architect CFA Voysey (1857–1941), found on designs such as 'the oak'. Voysey designed wallpaper and fabrics in the 1800's using his favourite nature-inspired motifs.

If a real room is your design inspiration, break it down into its key elements: colours, patterns, textures, fabrics and accessories.

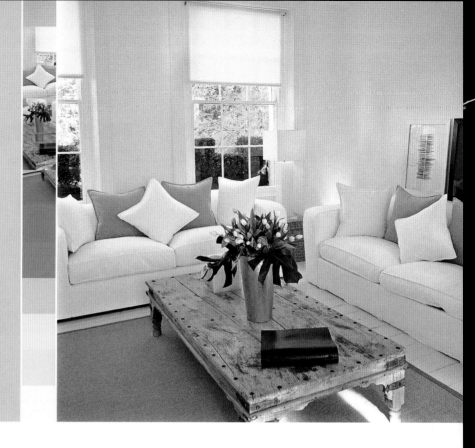

Real rooms aren't the only source of inspiration: nature, holidays – and holiday photos – as well as pictures in books and magazines can all give you ideas. Cut out and collect pictures of anything that catches your eye for its colour, texture or pattern – these will help you establish your own style. You can even incorporate objects: pebbles, string, seed pods, seashells and flower heads are all great sources of colour inspiration.

Spread all your images and objects out over a flat surface. Do you see an overall colour emerging? You may discover two or three colour schemes going on at this stage and will need to narrow the selection down. Finally stick your chosen images onto a big piece of card or paper. This is your mood board, and it will be an invaluable tool for matching colours for paint and other decorating materials – tiles, wallpapers, furnishing fabrics and floorings.

moodboards

Gather together colour swatches, samples, photos, pages torn from magazines, and any odds and ends that inspire you. A mood board will crystallise your ideas and help you make the right purchasing decisions.

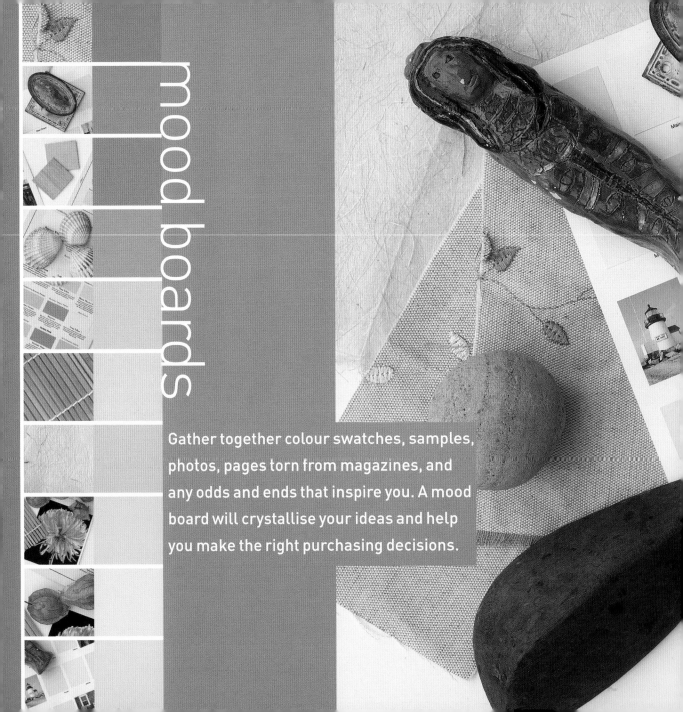

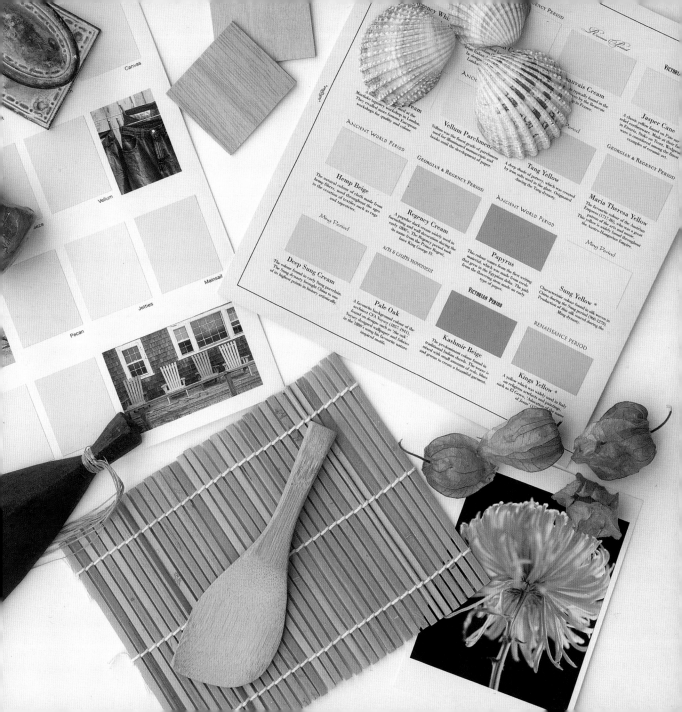

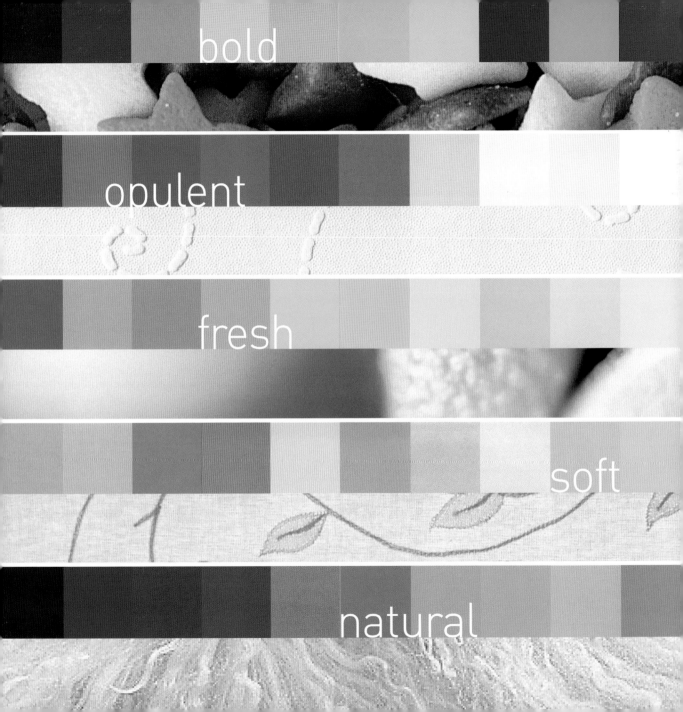

bold

opulent

fresh

soft

natural

colour
the senses

Colour is about style and character – but it's also about mood. Colour can make a real difference to how your home feels, and how you and your family live in it.

Bold, opulent, fresh, soft and natural: here we show how colour can create distinct moods, in different settings around the home. You might want a bright and brisk bathroom that will put a spring in your step first thing in the morning. Or a living room that will be a serene sanctuary in which to unwind each evening. Or maybe a cosy but sophisticated dining room where you can entertain friends late into the night. When planning a makeover, it always helps to start by thinking about how you use the room, or would like to use it.

Above all, your home should be about you: your character and your way of living. That is what you can achieve with colour.

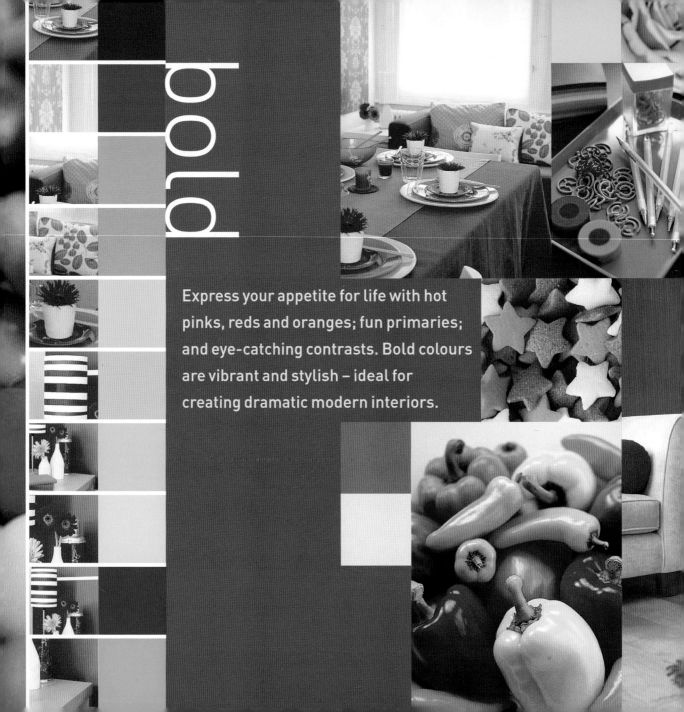

bold

Express your appetite for life with hot pinks, reds and oranges; fun primaries; and eye-catching contrasts. Bold colours are vibrant and stylish – ideal for creating dramatic modern interiors.

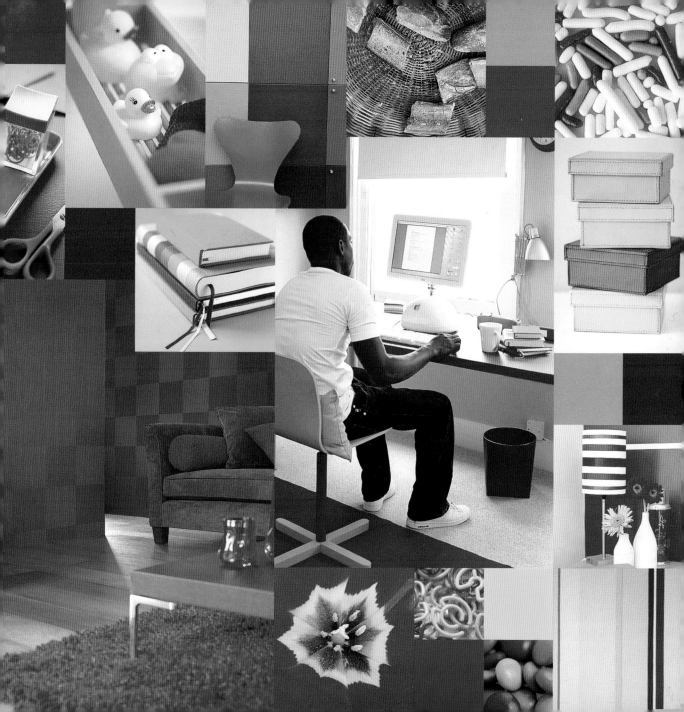

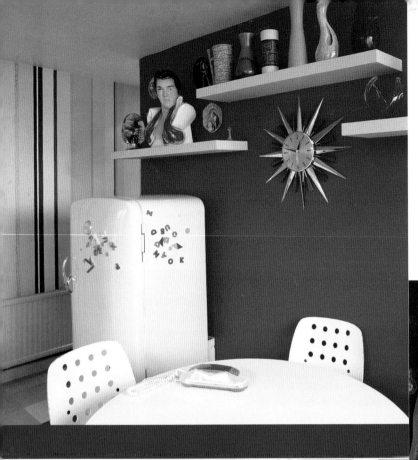

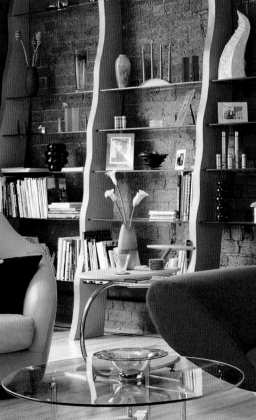

Nothing beats bold colours when it comes to making truly individual style statements in the home.

Colourful vertical stripes painted onto walls

Shelves displaying a collection of vases and ornaments

Multicoloured floor tiles

Stylishly practical furniture in plastic and painted metal

One bright red wall

Fun, colourful accessories

colour the senses

bold

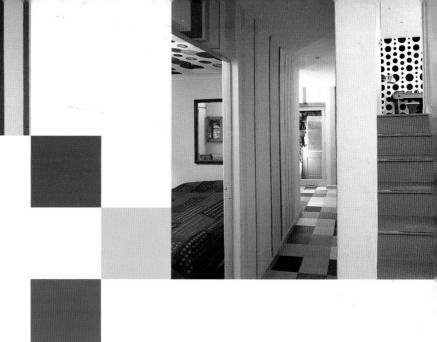

These rooms all use the three primary colours or rich shades of them. Such strong ingredients need careful handling. You can be daring and play bold colours off against each other, such as the blues of the striped wall panel and the red of the wall in the kitchen-dining room opposite. Or try balancing large areas of vivid colour with contrasting accents and calming natural tones like those of wood and brick, as in this loft-style living room, left. The hall and stairs above combine crazy colour and pattern to make a truly unique style statement. But even here there's a discipline at work: whole walls and ceilings of solid colour or white allow each pattern to sing out and define the space without overcrowding it.

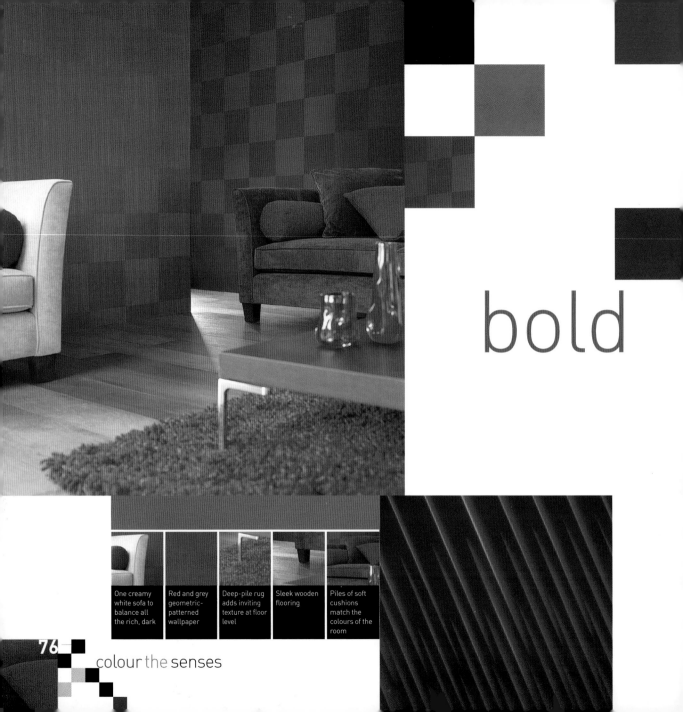

bold

One creamy white sofa to balance all the rich, dark

Red and grey geometric-patterned wallpaper

Deep-pile rug adds inviting texture at floor level

Sleek wooden flooring

Piles of soft cushions match the colours of the room

colour the senses

These rooms use similar colours in different proportions to achieve completely different moods. Rich red dominates the living room opposite, creating a contemporary but cosy atmosphere: these are sofas to curl up on and a rug to sink your toes into. In the home office, right, red is an accent rather than a base colour. The cool grey of the floor and geometric textured white wallpaper helps make the space feel generously proportioned. The result is a brisk and energising atmosphere – just what you need in a work area.

Storage boxes in minimal brown cardboard and aluminium

Textured geometric wallpaper

Stylish retro chair in black leather and chrome

Black trim details against slate grey vinyl flooring

Wall-mounted shelving painted brilliant red

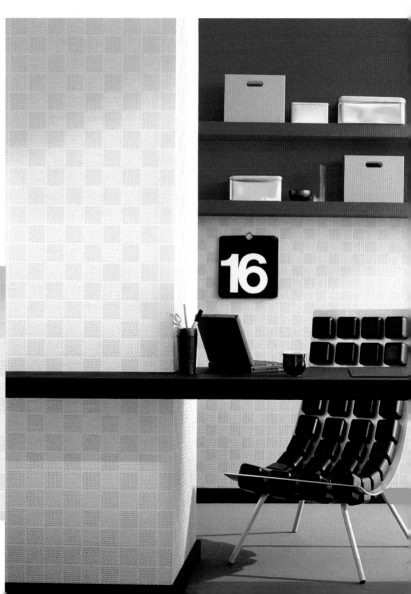

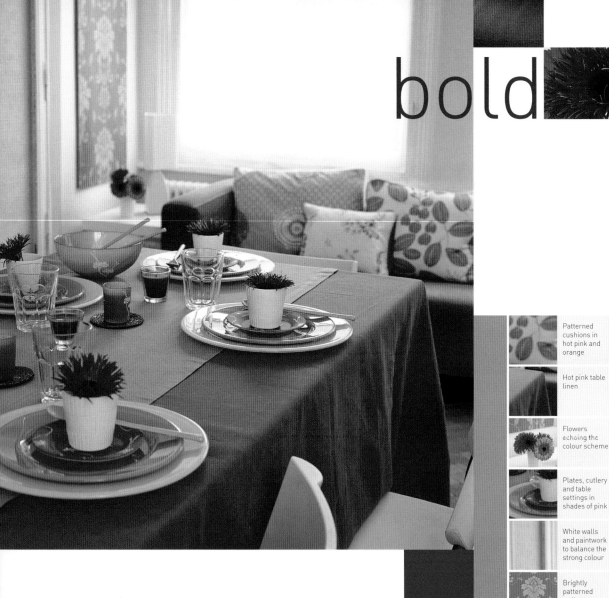

bold

Patterned cushions in hot pink and orange

Hot pink table linen

Flowers echoing the colour scheme

Plates, cutlery and table settings in shades of pink

White walls and paintwork to balance the strong colour

Brightly patterned wallpaper on a panel of MDF

colour the senses

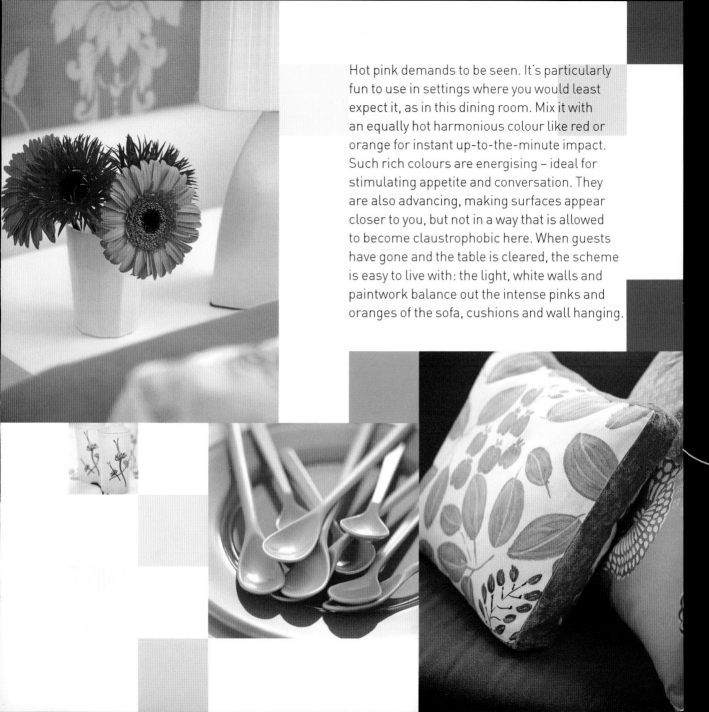

Hot pink demands to be seen. It's particularly fun to use in settings where you would least expect it, as in this dining room. Mix it with an equally hot harmonious colour like red or orange for instant up-to-the-minute impact. Such rich colours are energising – ideal for stimulating appetite and conversation. They are also advancing, making surfaces appear closer to you, but not in a way that is allowed to become claustrophobic here. When guests have gone and the table is cleared, the scheme is easy to live with: the light, white walls and paintwork balance out the intense pinks and oranges of the sofa, cushions and wall hanging.

bold

A home office is often installed in a box room or the smallest bedroom, where a receding colour like light blue will enhance what space there is. The bright sky blue used here is lightened by the glossy white woodwork and white blind that gives maximum control over incoming light – important for a workspace with a computer screen. The turquoise desk legs and chair introduce a second cool blue, while the desk top, rug, wastepaper basket and other details around the room are a stimulating bright red. These bold colours appear crisp and strong under the white light of halogen bulbs, as well as under natural light. They are ideal for a work and study environment, striking just the right balance between clear-headed calm and fun creativity.

colour the senses

Colourful files
and storage
boxes

Office furniture
painted in
coordinating
bright colours

Red rug

Roller blind
for maximum
control of
incoming light

Powder blue
walls and
white trim
details

Fun plastic
paperclips and
accessories

Stainless steel
desk lamp

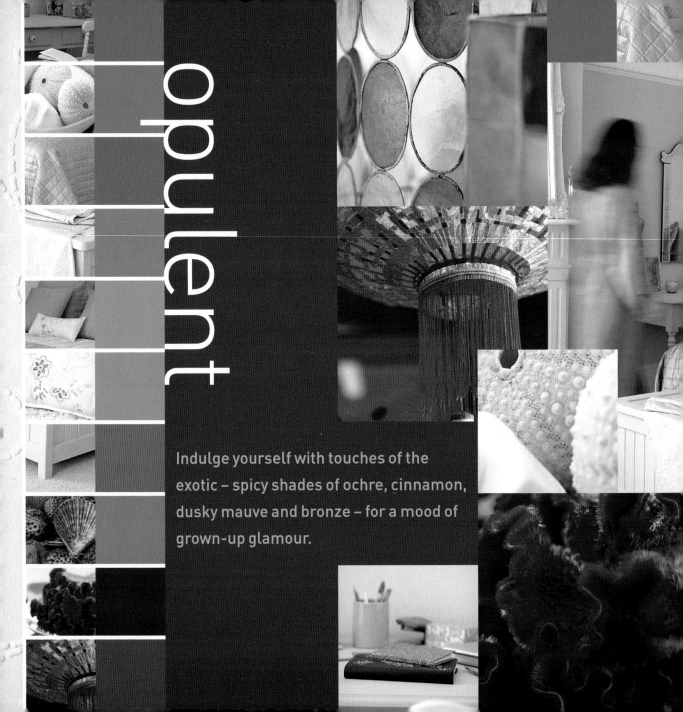

opulent

Indulge yourself with touches of the exotic – spicy shades of ochre, cinnamon, dusky mauve and bronze – for a mood of grown-up glamour.

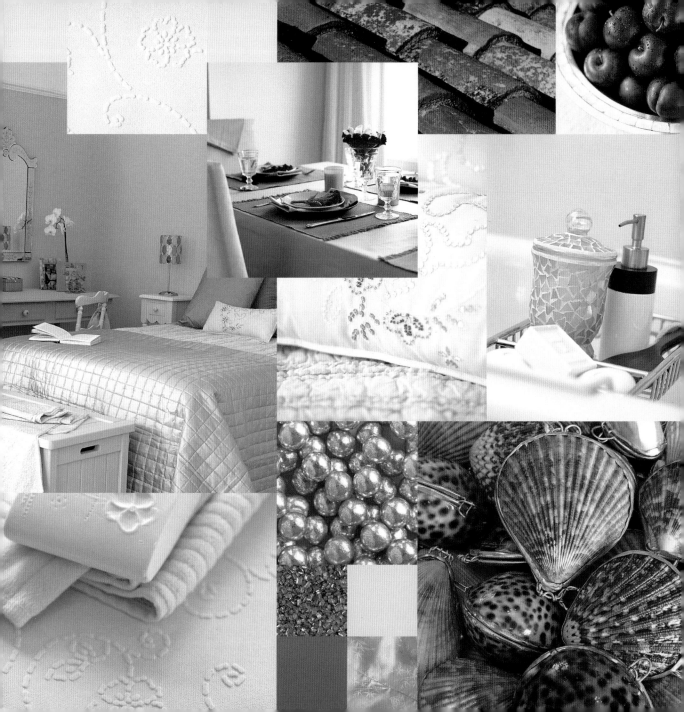

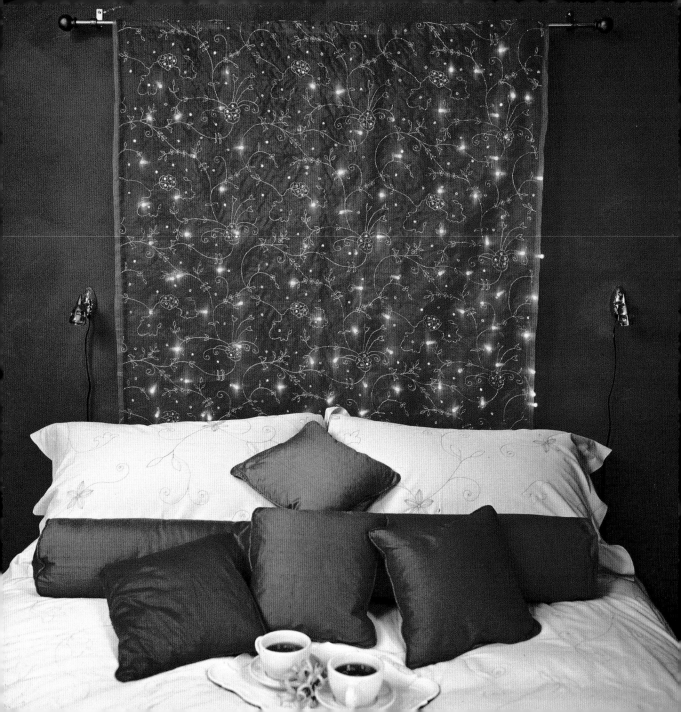

Deep orange-red walls

Wall hanging with fairy lights

Piles of orange and red cushions

Crisp white bedlinen with delicate embroidery

Hot shades of red and orange, cinnamon and gold bring a sense of luxury to a room. Cosy and sensuous by night, they can also be combined with cool textures and colours that will preserve a sense of openness by day.

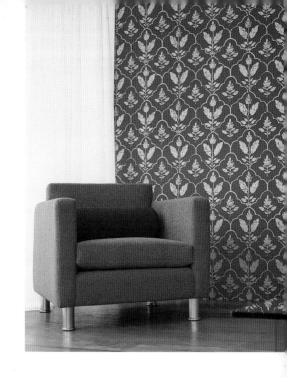

opulent

In this seductive bedroom, opposite, a touch of Eastern promise meets contemporary style with the delicate wall hanging spangled with fairy lights. Deep, spicy reds are beautifully enhanced by the contrast of cream or crisp white, like that of the embroidered bedlinen stacked with inviting cushions. A similar palette of colours adds up to a quite different mood in the living room above: past and present happily combine in the clean modern lines of the chair against the ornate wallpaper. The cool textures of the polished floor and chrome chair legs contrast the warm, advancing colours of the wall and chair. A white gauze curtain diffuses but doesn't diminish the incoming light, maintaining a sense of coolness and space in the room.

Layers of lilac, burnished bronze and mauve give a bedroom a luxurious atmosphere. Depending on how you use it, purple can be warm or cool. Here, pale, cool shades – closer to blue than red – make the room feel spacious and calm. The white upper wall, skirting and fireplace, as well as the old-fashioned ornate mirrors, create a sense of openness. By lamplight, glossy silks, embroidered and beaded textiles and glasswork accessories will come to twinkling life, adding to the opulent mood.

opulent

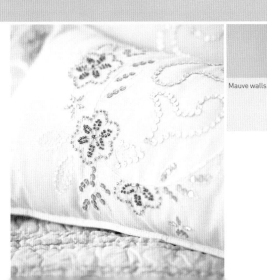

Mauve walls

Painted wooden furniture

Ornamental glass mirror frame

Glossy bronze quilted throw

Scatter cushions in harmonious shades

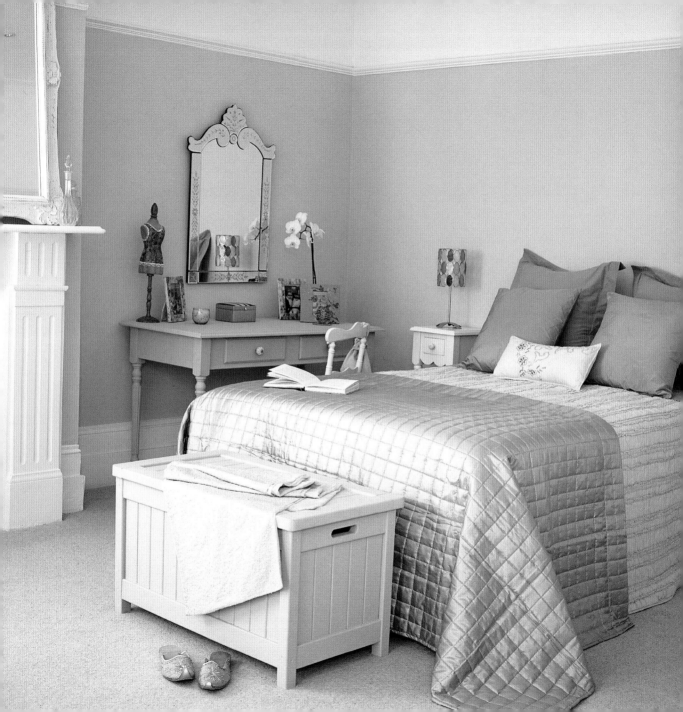

opulent

Opulent colours are perfect in a bathroom for relaxing and pampering in. Here the spicy terracotta wall, rich chocolate brown floor, and salmon-pink accessories all enhance the stylishness of the antique-look bath. Warm and dark colours like these absorb light, giving the space a cosy, inviting quality. Accessories with reflective surfaces, such as the mother-of-pearl tumbler and pewter bowl, add a touch of glamour, and the shells pick up the salmon, pink and white theme.

colour the senses

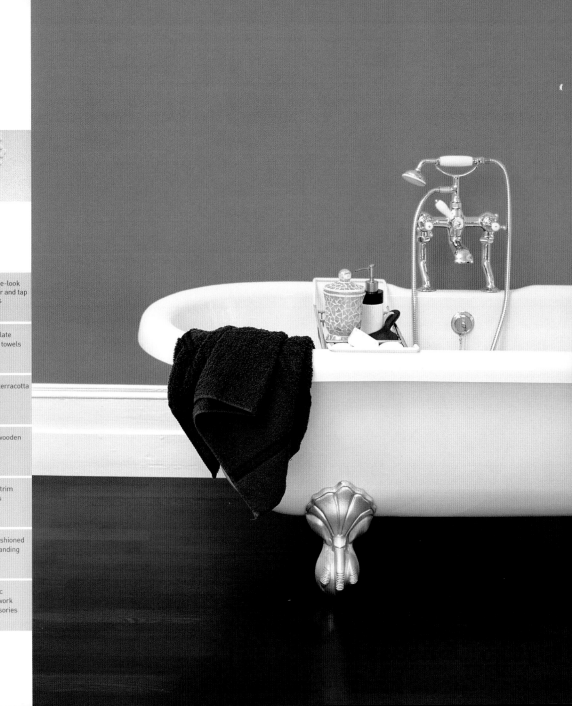

Antique-look
shower and tap
fittings

Chocolate
brown towels

Spicy terracotta
walls

Dark wooden
floor

White trim
details

Old-fashioned
freestanding
bath

Mosaic
glasswork
accessories

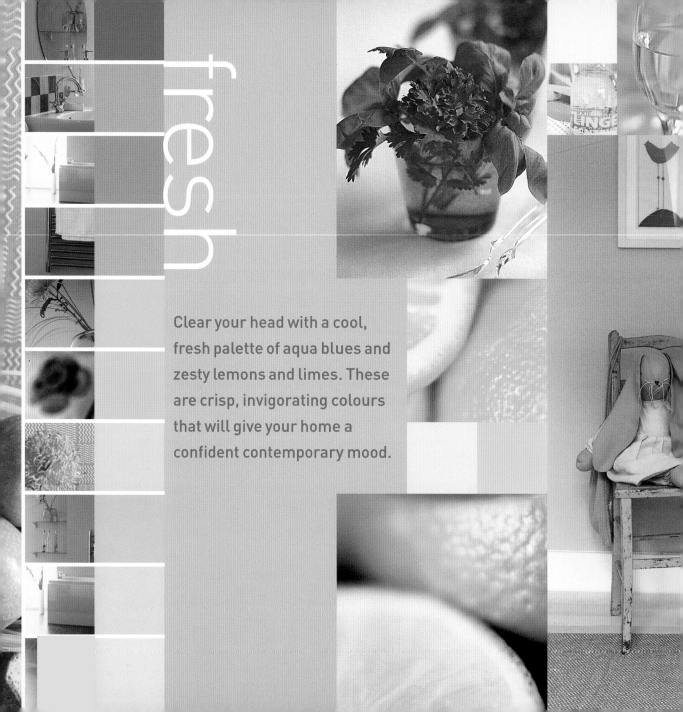

fresh

Clear your head with a cool, fresh palette of aqua blues and zesty lemons and limes. These are crisp, invigorating colours that will give your home a confident contemporary mood.

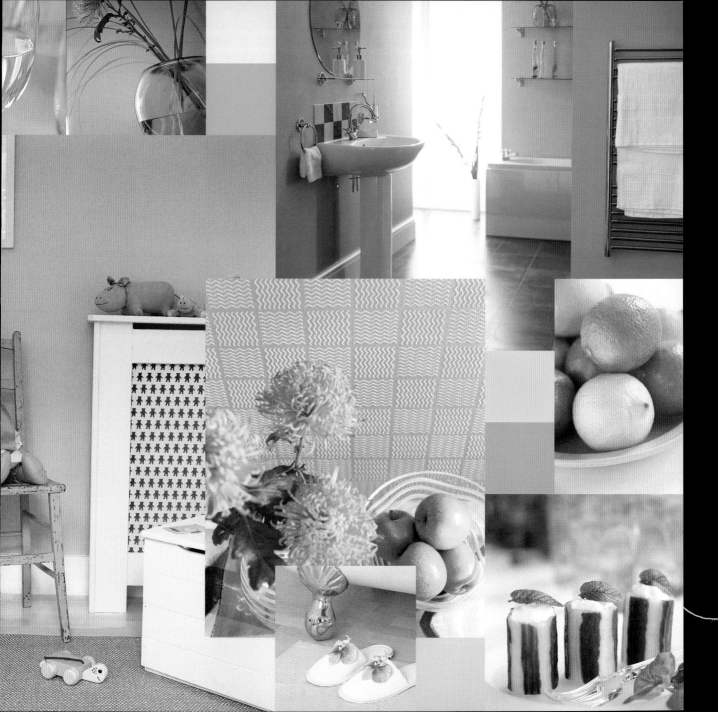

fresh

Fresh colours are pure and clean, making them an obvious choice for a bathroom. But their simplicity and vitality lend themselves to any part of the home.

Greens are usually regarded as cool colours, but they do have a natural brightness that adds a surprising warmth to a room, especially when they contain a high proportion of yellow. Being both relaxing and rejuvenating, yellow-greens are ideal for bathrooms. Here, the calm, restful wall colour and the generously proportioned antique-style bathtub set a mood of easy elegance, yet the room remains practical and functional. White-painted skirting, shiny chrome bath feet and fittings, and the natural pine flooring give a light, bright, brisk feel to the space.

colour the senses

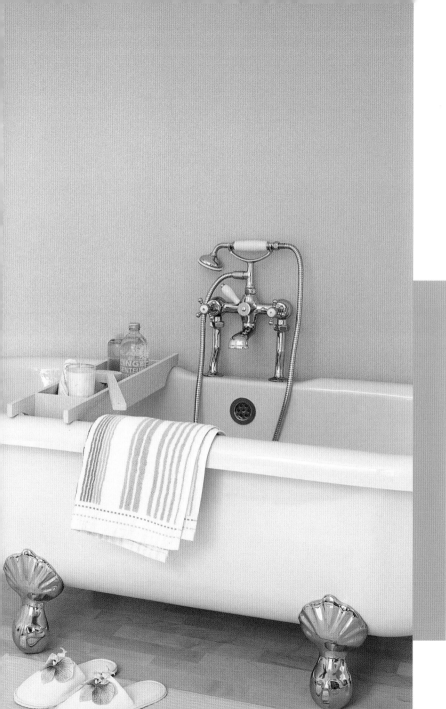

Zesty yellow-green walls

Wooden bath rack painted to match the walls

Striped towels in green, lime and aqua blue

Lime green bath mat

White skirting board

Pine-effect laminate flooring

Shiny chrome taps and shower head

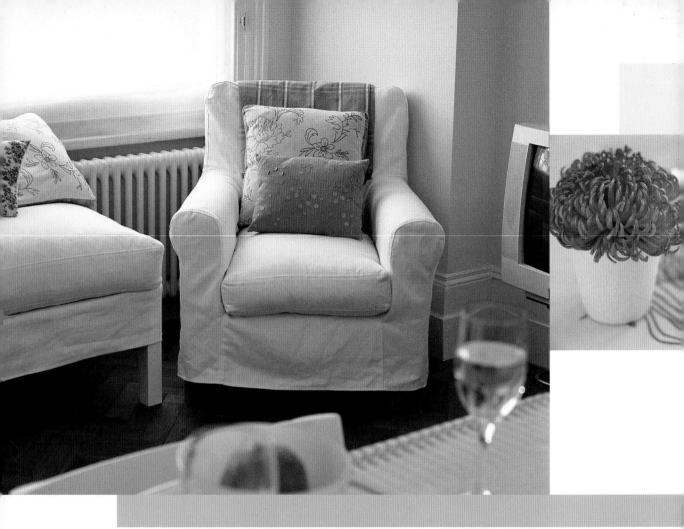

White walls and upholstery; colour is all in the detail

Classic parquet flooring

Loose chair covers in cool, comfortable linen

Cushions mix stripes, checks and florals

Contemporary pale green television set

Simple white ceramic and glass tablewares

Crisp white tablecloth with turquoise pattern detail

Green chrysan-themums in white ceramic cup vases

colour the senses

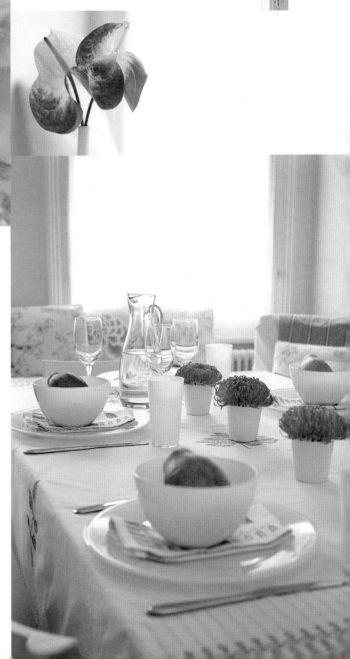

fresh

A predominantly white colour scheme is very versatile: accessories, wall hangings, flowers, plants, soft furnishings and cushions are all opportunities to introduce vibrant accent colours, which will be enhanced by the crisp white backdrop. They can also be changed with the seasons or even your mood. Here, the classic combination of blue and white is given a zesty contemporary twist by the addition of lime green. The cushions combine these accents in a mix-and-match collection of checked, striped and floral patterns.

fresh

Layers of green, lime and yellow bring a spring-like freshness to a child's room. The radiator cover, painted sunshine yellow, subtly stands out from the more muted greenish-yellow of the wall behind. The same colours also brighten up an ordinary chest of drawers. The overall impact is calmed by the natural tones of the floor and rug. The cot and mattress cover bring in touches of powder blue, a harmonious colour which adds to the restful quality of the room.

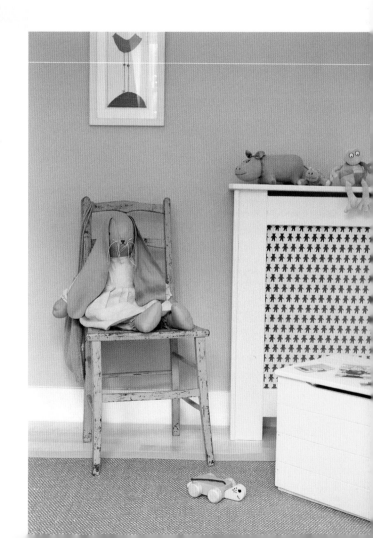

colour **the senses**

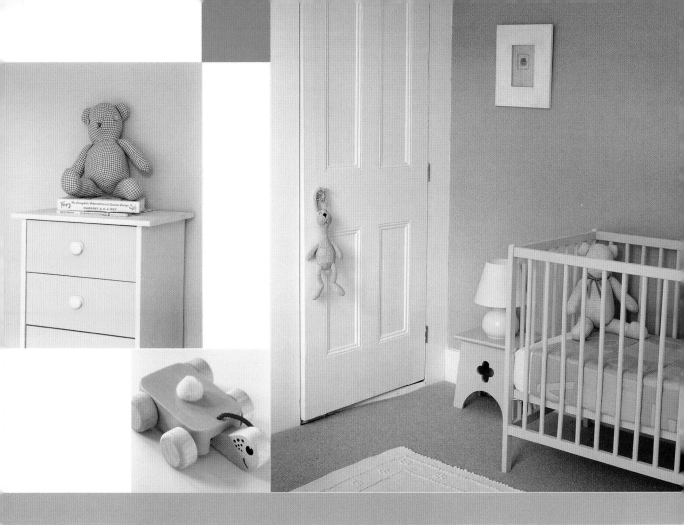

 Soft beige
carpet

 Drawers
painted green
and yellow

 One wall
painted yellow,
one white

 Radiator cover
painted bright
yellow

 Cot painted
powder blue

 White rug

 White door and
woodwork

 Favourite old
chair and toys

 Prints in
simple shapes
and bright
colours

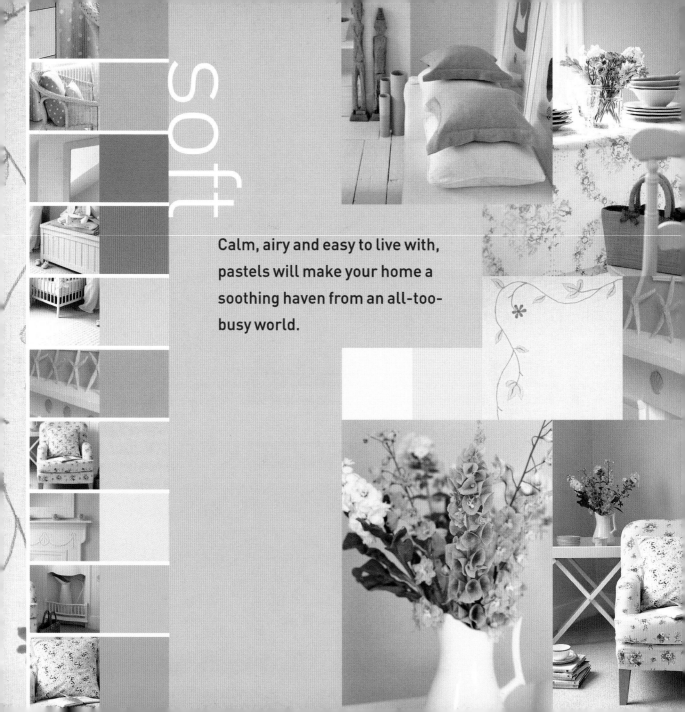

soft

Calm, airy and easy to live with,
pastels will make your home a
soothing haven from an all-too-
busy world.

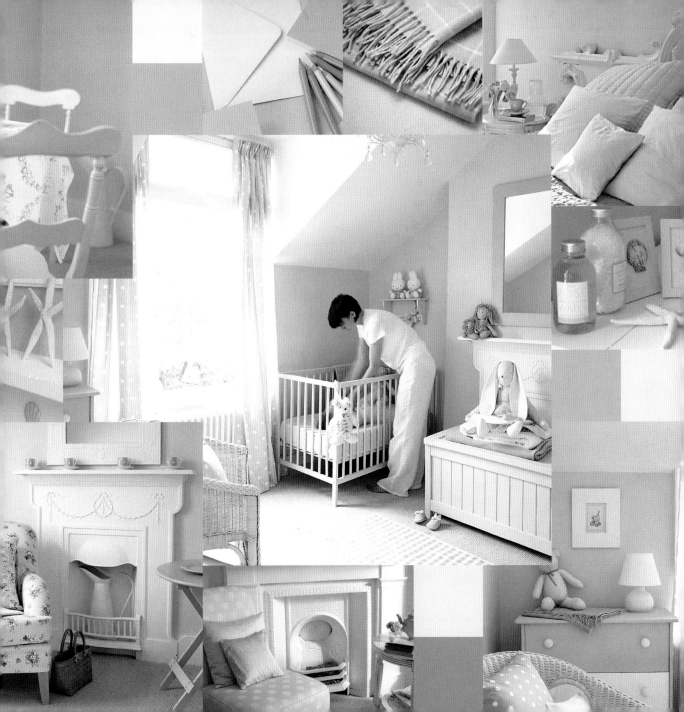

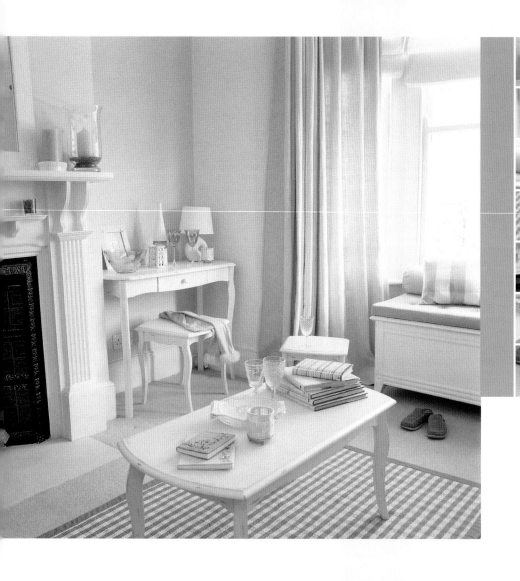

Candles for ornament by day, ambience after dark

Pale curtains and blinds to softly filter the light

Lilac and white check-print cushion

Rug in smaller lilac check pattern

White walls and woodwork

White-painted wooden furniture

Oatmeal carpet

Delicate shades of rose pink,
lavender, duck-egg blue and
soft chalky green – pastels have
a timeless and classic appeal.

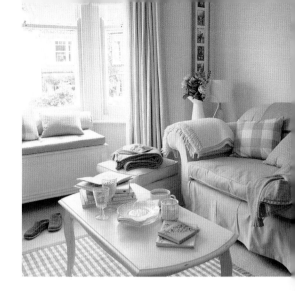

soft

Pale pastel tints mix happily with each other and
never fail to create a sense of calm. Elegant lilac
brings a serene mood to this living room. Pastels are
ideal in our cool northern light, which draws out their
subtlety and softness. Lilac can shift from silvery
grey to pale blue as the light changes through the day.
At night, under soft pools of lamplight, it's invitingly
warm. Cushions and a fluffy woollen throw invite you
to sit back and relax.

Pastel colours need not be confined to the walls:
painted furniture, and furnishings in cool cottons and
fine wools, add to the calm mood. Or for a more
contemporary feel, you could combine pastels from
opposite sides of the colour wheel, and introduce
unexpected textures like suede, brushed steel or
chrome.

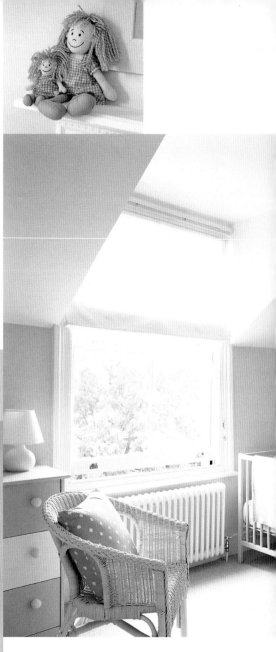

soft

Pale blues and pretty pinks are classic nursery colours, sweet as an ice-cream sundae. Light blue and white on the walls and sloping ceiling keep this room feeling open and calm, while pink furniture and furnishings add warmth. The two colours are in shades of a similar value, and not too pale – pastels can be fun as well as delicate. The neutral flooring is practical and adaptable: it will work just as well with a more grown-up colour scheme in a few years' time.

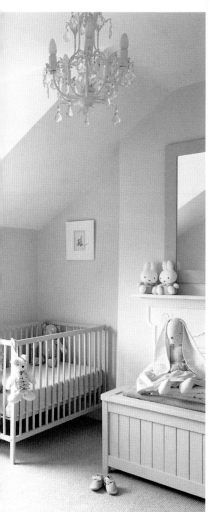

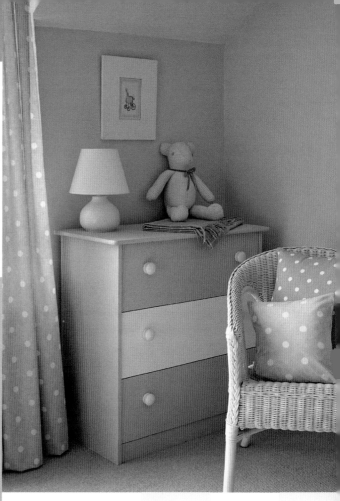

Mirror frame painted soft pink

Powder blue walls and white ceiling

Cot and storage box painted soft pink

Chandelier light fitting

Cute polka dot prints

Chest of drawers painted pink and white

Painted wicker armchair

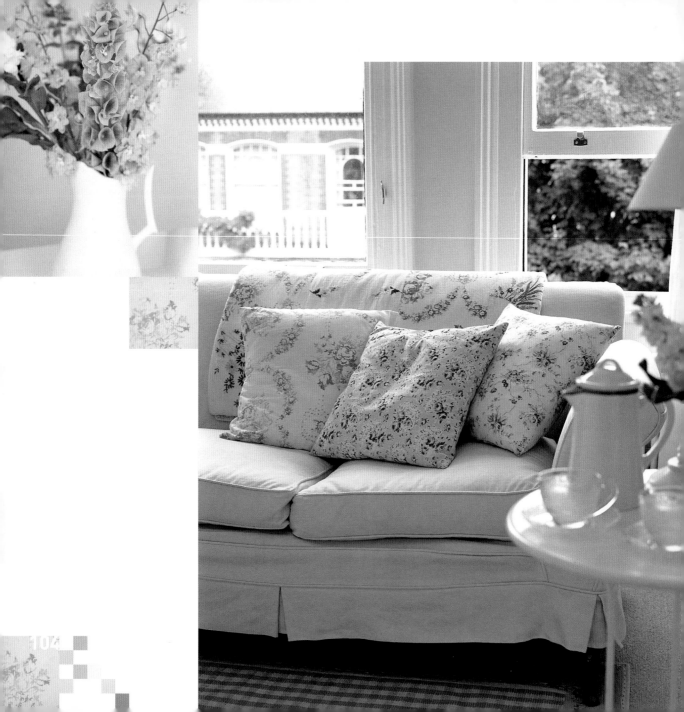

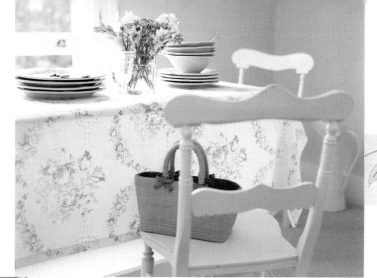

Elegantly turned wooden lamp stand

Mix and match floral prints

Oatmeal carpet

Sofa covers in heavy, cool off-white cotton

Pale pink walls and white woodwork

Pink and white flowers echo the cushion prints

soft

You don't have to live in a country cottage to have a taste for country cottage nostalgia. The vintage look has made a real comeback. The way to bring it up to date is to use pattern as an accent rather than across large surfaces, and not to worry about matching all your prints. Checks, florals, stripes: it's fine to mix and match designs so long as the colours are similar. Add some pretty plates, glasses and summer flowers and the scene is set for informal dining.

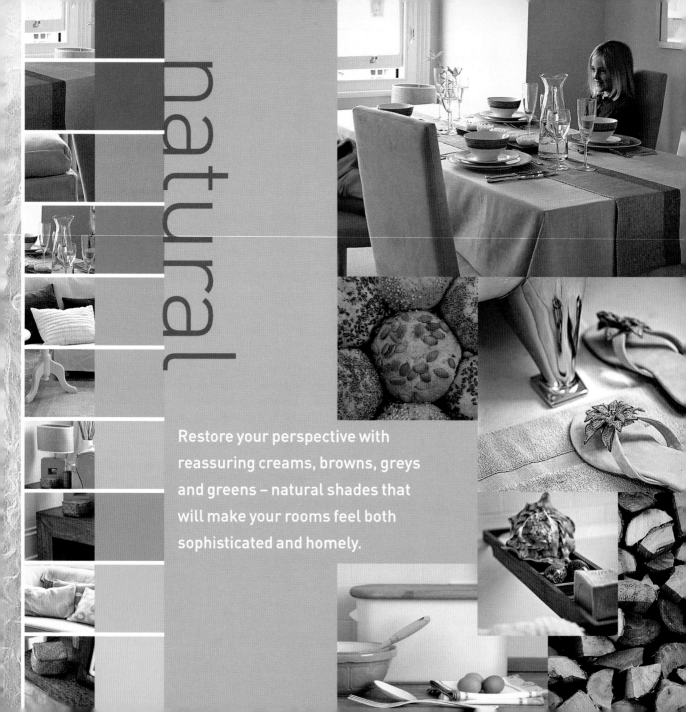

natural

Restore your perspective with reassuring creams, browns, greys and greens – natural shades that will make your rooms feel both sophisticated and homely.

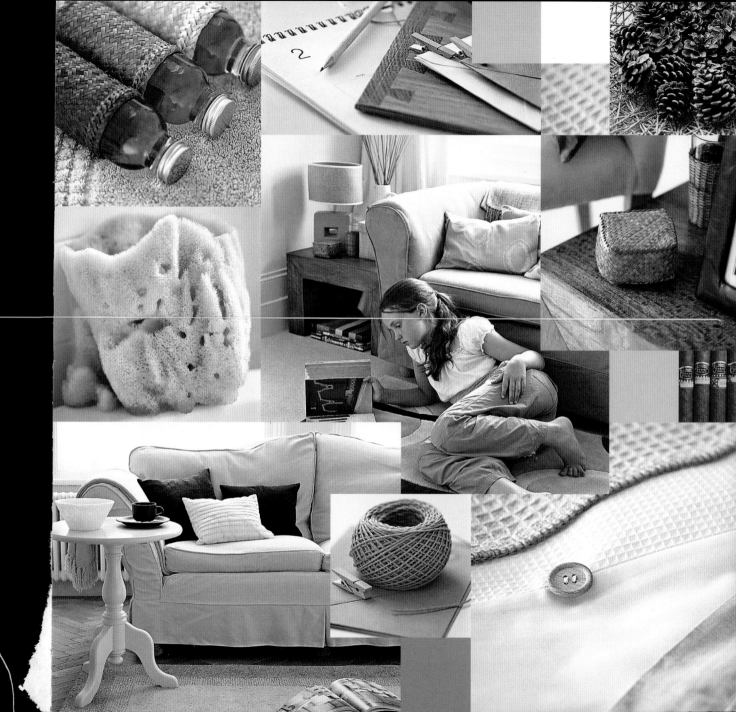

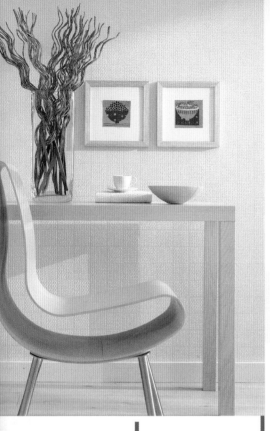

A natural palette is one of the easiest to work with – just think layers. Layers of colour, texture and even pattern.

The rich warm tones of natural shades harmonise effortlessly – you can easily use half a dozen or more variations in a single room. They also help to create a feeling of calm, space and light. Honey-coloured wood and creamy buttermilks (left) create a classic contemporary look, and are a great backdrop for stronger colours, such as the burnt orange in the prints on the wall. In this living room (opposite), texture and pattern become all important in setting the mood. Smooth calico and knobbly linen; raffia and stone; wood and a display of cut grasses all contribute to the understated style. Cushions with a circular motif are a perfect highlight on a plain sofa. Their patterns are echoed by the circular lines of the lamp and the velvet-textured rug.

natural

colour the senses

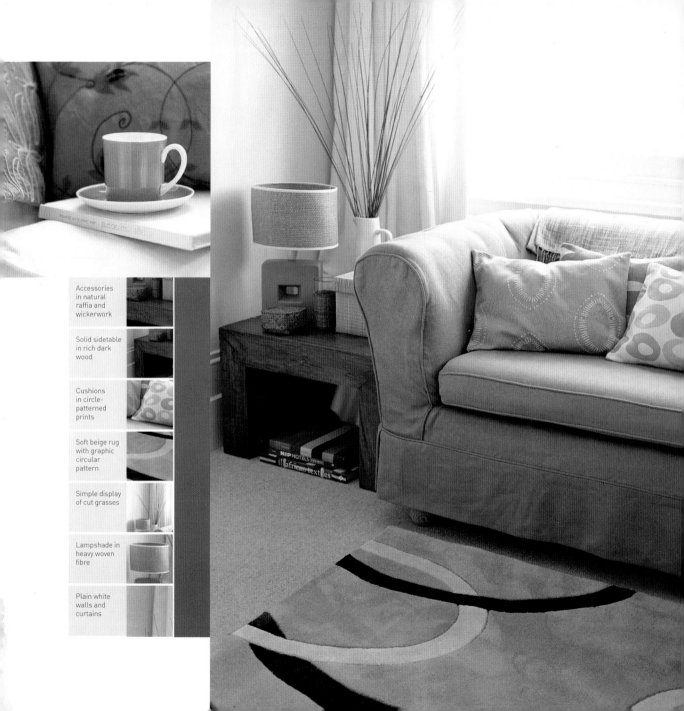

Accessories in natural raffia and wickerwork

Solid sidetable in rich dark wood

Cushions in circle-patterned prints

Soft beige rug with graphic circular pattern

Simple display of cut grasses

Lampshade in heavy woven fibre

Plain white walls and curtains

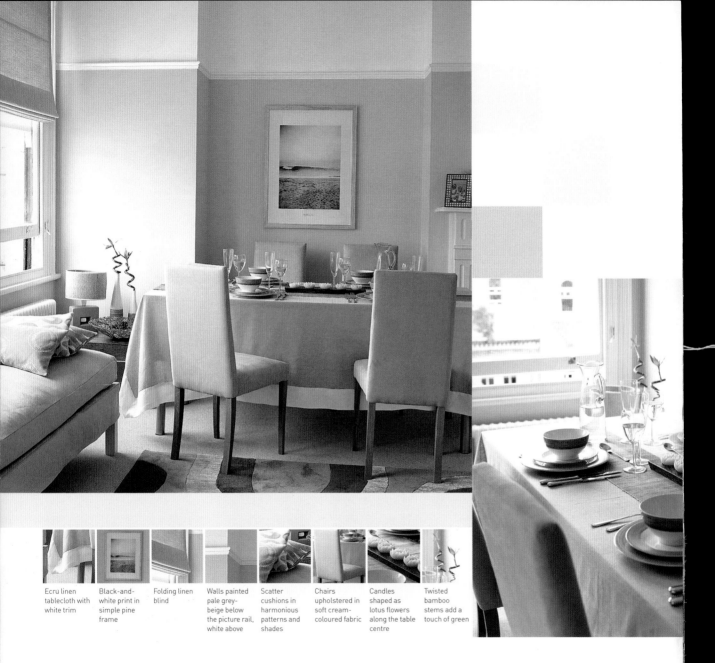

Ecru linen tablecloth with white trim

Black-and-white print in simple pine frame

Folding linen blind

Walls painted pale grey-beige below the picture rail, white above

Scatter cushions in harmonious patterns and shades

Chairs upholstered in soft cream-coloured fabric

Candles shaped as lotus flowers along the table centre

Twisted bamboo stems add a touch of green

natural

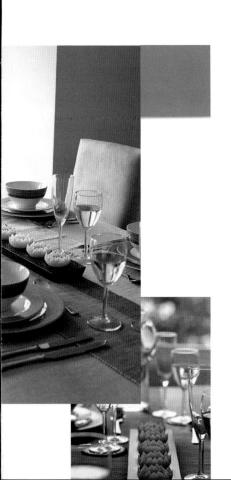

Shades of cream, beige, ecru and golden brown immediately dispel any hint of chill, making them perfect for north-facing rooms. They also help when you want to emphasise a sense of spaciousness, as in this living-dining room. In the absence of bold colour, subtle variations in texture really come to the fore, whether it be the linen tablecloth, wooden picture frame or soft fabric of the chairs. Small design details also stand out more: twisted bamboo stems, candles shaped as lotus flowers, and a sculptural lamp base. In the kitchen above, the warm tones of natural wood soften the clinical whiteness of the scheme.

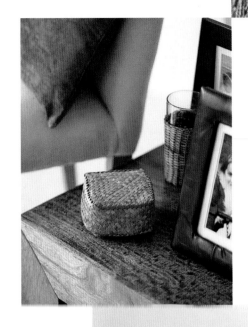

natural

The contrast of rich chocolate brown with palest cream brings real sophistication to a natural room scheme. The tactile qualities of your materials are probably more important in a bedroom than anywhere else in the house: think silk, linen, cashmere, suede and fur. Layers of inviting texture will work with layers of warm natural colour to make this a room you are happy to be in day or night.

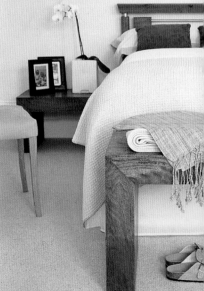

| Woven, tasselled throws | Accessories in natural materials | Creamy white linen and rich chocolate brown cushions | Inviting textures: soft suede and fake fur | Heavy woven cream bedspread | Elegant white orchid | Wooden tables and bedframe | Soft stone-grey walls |

colour the senses

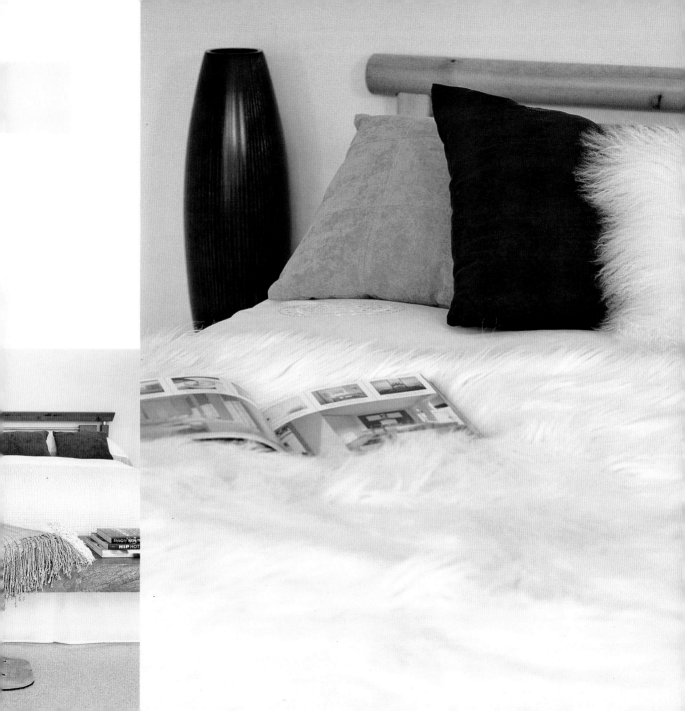

natural

Natural colours are not only easy to work with and easy to live with, but they are very versatile. You can transform them with splashes of hot, strong colour, like the orange that lifts the mood of this predominantly brown and white living-dining room. When working with accent colours, it helps to be consistent – stick to two or three closely related shades for a coherent effect. And remember you can change your accent colour to suit the mood, season or occasion.

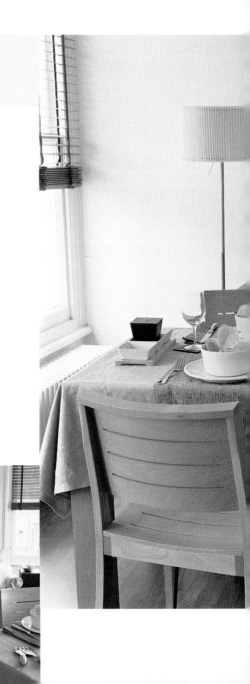

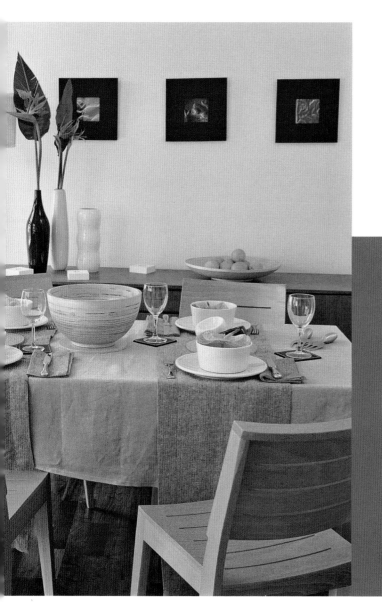

Photos in matching dark frames

Tableware and accessories in natural materials

Warm orange accents lift the predominantly brown palette

Orange bird-of-paradise flowers

Wooden slatted venetian blind

Wooden dining chairs

Beige linen tablecloth with orange runners

colour the senses

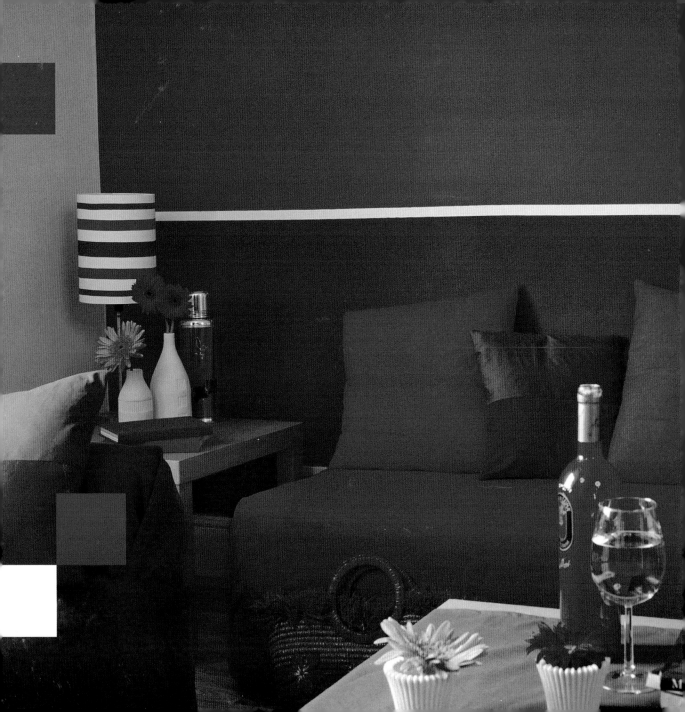

colour
at home

Traditional ways of trying out new decorative ideas have never been very confidence-inspiring. A sample square of flooring or wallpaper, a tester pot of paint daubed on one wall: how can you possibly judge what they will look like across the whole floor or wall? Or how they will affect the levels of light or the feel of the space?

So here we show you colour in action. Exploring the modern home room by room, we demonstrate stylish colour recipes that complement the many different ways we use our living space. At last you can really see the effects of different colour schemes, and compare them one against another. You can really see how to make colour work for you.

OSAIC WORKSHOP

For most of us, the kitchen is much more than just somewhere to prepare food. It's the hub of the home, the place we eat, do homework, hobbies and laundry, or hang out with family and friends.

kitchens

fresh

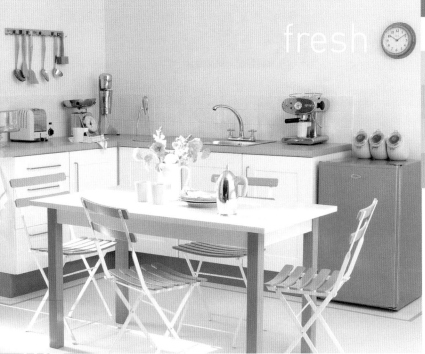

Chairs and table in sophisticated grey-green and white

Splashback of soft green tiles along the worktop

Appliances and accessories in matching colours

Walls painted in two closely related shades

Sea green and white tiles in a random pattern

Mosaic tile splashback in soft neutrals

Light grey floor tiles

Walls painted two shades of blue

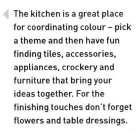

The kitchen is a great place for coordinating colour – pick a theme and then have fun finding tiles, accessories, appliances, crockery and furniture that bring your ideas together. For the finishing touches don't forget flowers and table dressings.

colour at home

ocean

cheerful

Colour can help enhance a kitchen's many functions. Think about the time of day you use yours most, and the mood you want to create. In kitchen–dining rooms, it's particularly important to allow plenty of control over the lighting, so you can dim or switch off the brighter lights of the work zone to leave the dining area in softer, more subtle light. Choose materials that will suit the room's functions: surface colours and textures need to withstand changes in temperature, as well as washing and wiping.

Most of us cook as well as eat in the kitchen these days – so the styling and decoration has to look just as good at lunchtime as over a candlelit supper. A light-coloured floor always makes a room feel bigger and brighter, and two tones of colour on the walls will look cheerful by day and sophisticated in the evenings.

colour at home

119

efficient

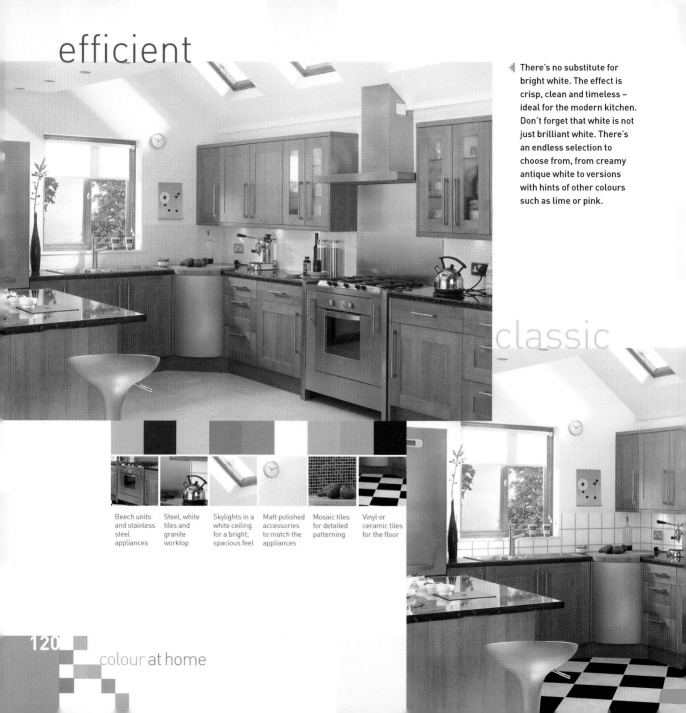

There's no substitute for bright white. The effect is crisp, clean and timeless – ideal for the modern kitchen. Don't forget that white is not just brilliant white. There's an endless selection to choose from, from creamy antique white to versions with hints of other colours such as lime or pink.

classic

Beech units and stainless steel appliances

Steel, white tiles and granite worktop

Skylights in a white ceiling for a bright, spacious feel

Matt polished accessories to match the appliances

Mosaic tiles for detailed patterning

Vinyl or ceramic tiles for the floor

colour at home

sophisticated

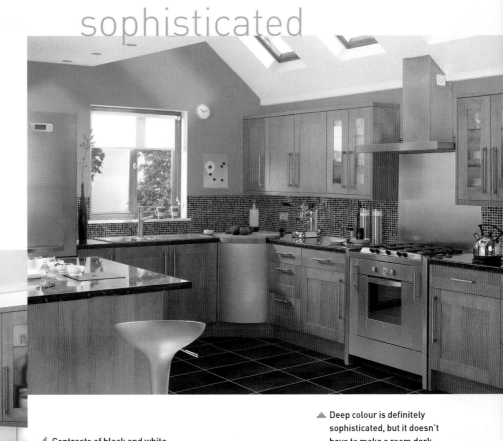

◁ Contrasts of black and white are always striking, and will transform any room. Running tiles in a diagonal pattern across the room will enhance the sense of space. A simple splashback of white tiles completes this classic look.

⬥ Deep colour is definitely sophisticated, but it doesn't have to make a room dark. Painting the ceiling white adds space and light to this kitchen, while the mosaic tile splashback picks up the colour of the slate-effect laminate floor.

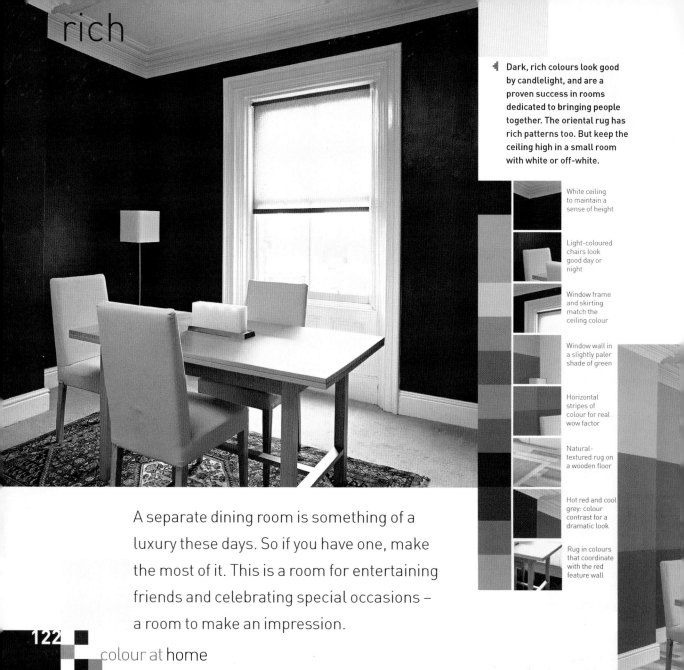

rich

Dark, rich colours look good by candlelight, and are a proven success in rooms dedicated to bringing people together. The oriental rug has rich patterns too. But keep the ceiling high in a small room with white or off-white.

White ceiling to maintain a sense of height

Light-coloured chairs look good day or night

Window frame and skirting match the ceiling colour

Window wall in a slightly paler shade of green

Horizontal stripes of colour for real wow factor

Natural-textured rug on a wooden floor

Hot red and cool grey: colour contrast for a dramatic look

Rug in colours that coordinate with the red feature wall

A separate dining room is something of a luxury these days. So if you have one, make the most of it. This is a room for entertaining friends and celebrating special occasions – a room to make an impression.

dining rooms

Dining rooms have traditionally been decorated in rich, strong colours because they were used mainly for formal evening meals. Lifestyles may have changed, with dining rooms often put to other uses by day, but they can still offer great scope for style statements and bold, dramatic colours.

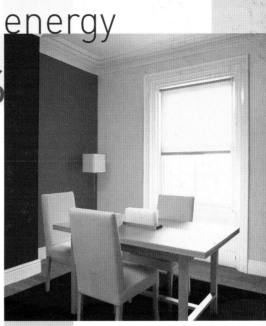

Hot brights with cool blue and grey: a mix of Scandinavian simplicity and Oriental energy that will be light and airy by day, but intimate and cosy after dark.

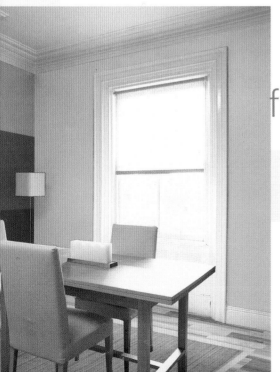

forest

Inspired by a woodland theme these stripes create a striking flow of colour. The adjacent walls are painted a slightly paler tint of green, while the strong wall pattern is offset at ground level by a classic wood floor and plain rug.

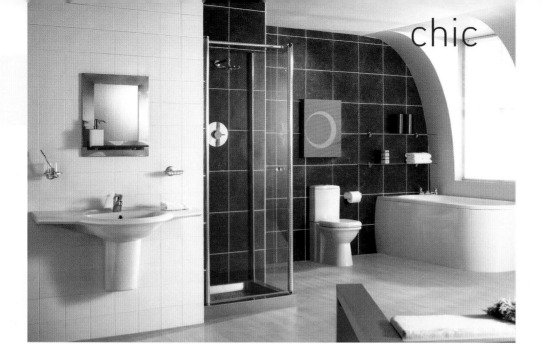

chic

Natural colours and textures like these large slate wall tiles and water-resistant wood laminate floor add chic to a simple white bathroom.

awake

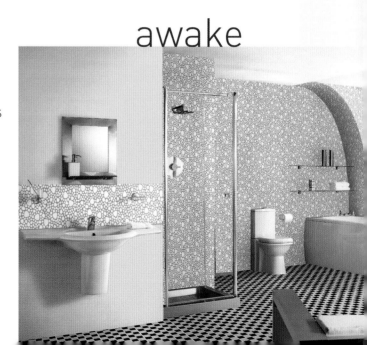

The way you use your bathroom holds the key to its style. A busy family bathroom needs to be unfussy, practical and energising. But a bathroom can also be a cosy retreat, a place to pamper yourself and relax.

grand

Play with tiles and mosaics to create contrasting patterns and colours – a smaller tile size for a larger area works well. Balance dark walls with a pale floor such as lime-washed effect wood laminate.

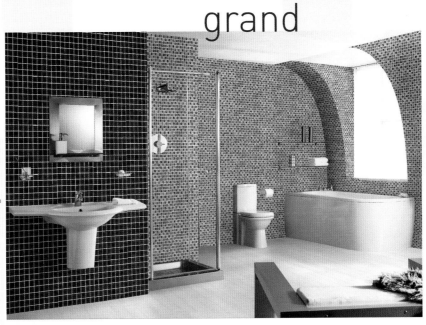

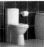

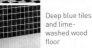
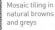

Glass shelves for a clean, modern look

White bathroom fittings work with any colour scheme

Contrasts of colour and texture

Small chequerboard floor tiles laid at an angle

Deep blue tiles and lime-washed wood floor

Mosaic tiling in natural browns and greys

Wake up to zesty yellow, orange or lime: bold colour can give a real lift to a bathroom. If you tile the floor, take away the chill with underfloor heating.

bathrooms

White is a useful colour in bathrooms as it creates a bright, efficient atmosphere. It doesn't have to be clinical – add lively accent colour in tile details, bath panels, blinds, towels and accessories. Alternatively, Mediterranean-style turquoises and blues or fresh citrus shades of yellow and green are brisk and invigorating – as well as cooling after a hot bath or shower. For a private boudoir setting, try rich reds or opulent purples, with candles, a soft rug and even tropical plants to set the luxurious mood.

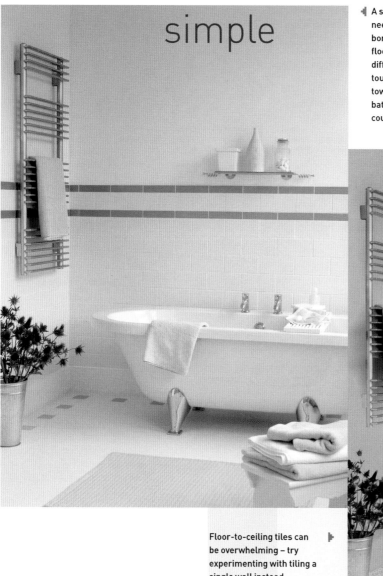

simple

◀ A simple white-tiled bathroom need not be boring. Soft grey border tiles and blue inset floor tiles make all the difference here. Add finishing touches such as matching towels and bathmat. In a small bathroom it's the details that count.

boudoir

Floor-to-ceiling tiles can be overwhelming – try experimenting with tiling a single wall instead. ▶

colour at home

Cool fresh blues are a natural choice for a bathroom. Create a harmonious mood by painting adjacent walls in slightly different shades. For warmth underfoot, consider cork tiles or a wooden floor.

harmony

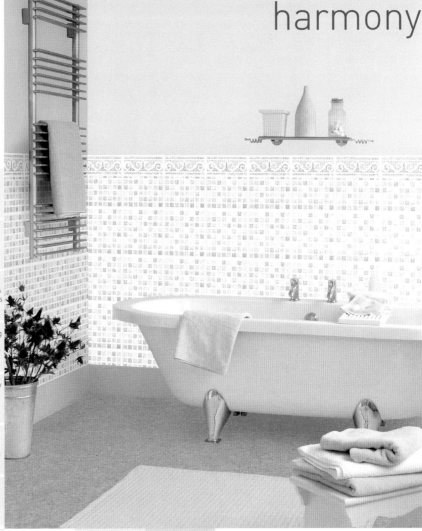

Double row of border tiles for extra impact

Pale blue bathmat and towels match inset floor tiles

Wall-mounted glass shelf with simple brackets

Floor-to-ceiling tiles balanced by a plain white wall

Neutral creamy beige for the skirting board

Mosaic-effect tiles in soft natural colours

Two shades of blue create a harmonious mood

For a floor that feels warm, choose cork, vinyl or wood

The living room is the focal point and natural showpiece of many homes. It needs to be comfortable and practical – but above all, an expression of you.

friendly

fun

▲ Warm and friendly, rich and welcoming – you can use deep reds with dramatic effect in the living room. By colouring just one feature wall, you will minimise the space-reducing effect of such deep shades.

It's fun to be frivolous with colour. Inspired by wallpaper, you can make your own unique designs in paint. This striking spot pattern is calmed by its neutral colour scheme and closely related tones.

128 colour at home

Create your own modern art. ➤ Dark floors, neutral walls, and a striking leather sofa are the ideal backdrop to a feature wall painted in sparklingly energetic colours.

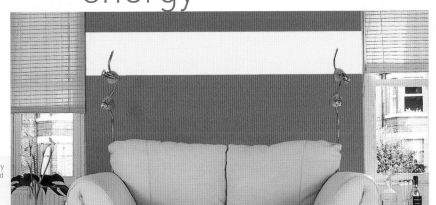

Contemporary print mounted on a rich red wall

Modern lights for reading and atmosphere

Experiment with your own patterns

Chrome sofa legs against a dark floor

Feature wall defined by an eyecatching stripe

Classic leather upholstery

living rooms

This room is both a private and public space: somewhere to be hospitable, but also to spend time alone or with family. It might also be an area for children to play. Cool colour schemes will lend sophistication to a large living room and preserve a sense of space in a small one. Patterned and textured wallpapers can add a touch of elegance, especially in rooms without any period features. Or get really creative with bold colour and pattern: a feature wall like these will make a stunning centrepiece in any living room.

contemporary

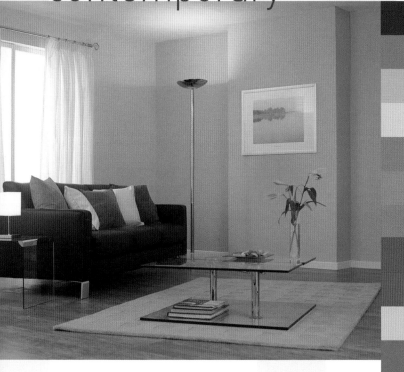

Framed print provides a highlight on the soft grey wall

Sheer curtains let the light through

Cushions that contrast and cushions that match

Walls painted two different shades of fresh green

Fresh flowers for colour, texture and fragrance

Print mounted on feature wall

One hot orange wall is the centrepiece to the room

Cushions and flowers echo the colour of the feature wall

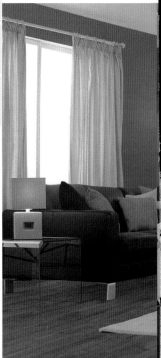

⚓ Enjoy the sophistication of neutrals – contemporary and easy to live with, as well as an ideal backdrop to pictures, prints, and clean-cut modern lights and furniture.

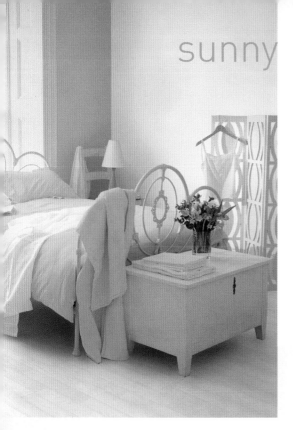

Inviting textures like sheepskin, soft wool or cool crisp linen will contribute to a comfortable, relaxed ambience in a bedroom. Carefully planned lighting will also make all the difference here: a dimmer switch to control the main ceiling or wall lights, as well as a selection of lamps about the room, will allow you to brighten or soften the mood with ease.

▲ Here the whitewashed furniture and floor are brightened by a playful combination of light blue and creamy yellow. The bedlinen matches the wall colours.

Rich wood tones combined with deep warm reds create a completely different atmosphere of cosy, rustic simplicity.

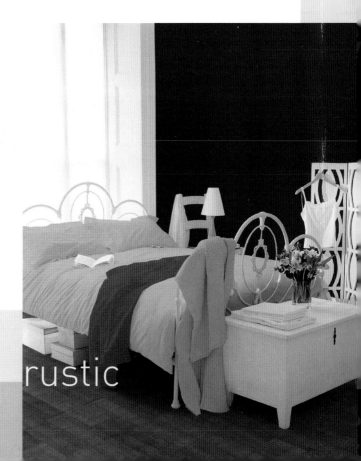

rustic

light

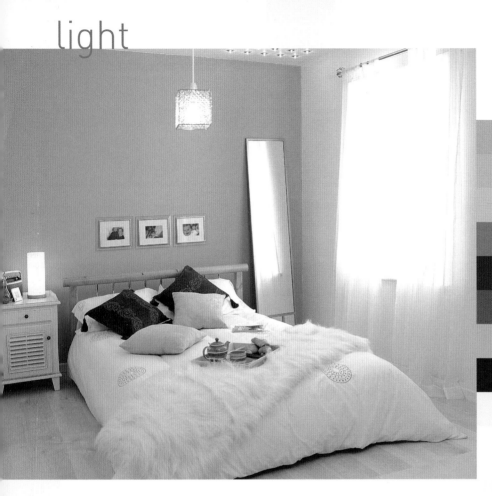

Pale blue wall enhances light and space in the room

Scatter cushions bring colour to the pale bedlinen

Painted stripes curve dramatically across the wall

Rich dark flooring creates a cosy, intimate mood

Wallpaper with contrasting pattern

Simple low headboard accentuates the space

⚓ The white wall, curtain and bedlinen against a light-coloured laminate wood floor give a bright and spacious feel to this bedroom, while one sky-blue feature wall injects vitality.

bedrooms

☛ Pale green wallpaper,
limewashed wooden floor,
and the simple comforts of
crisp white bedlinen – this
is a bedroom with all the
freshness of a spring morning.

spring

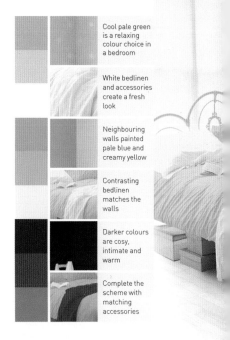

	Cool pale green is a relaxing colour choice in a bedroom
	White bedlinen and accessories create a fresh look
	Neighbouring walls painted pale blue and creamy yellow
	Contrasting bedlinen matches the walls
	Darker colours are cosy, intimate and warm
	Complete the scheme with matching accessories

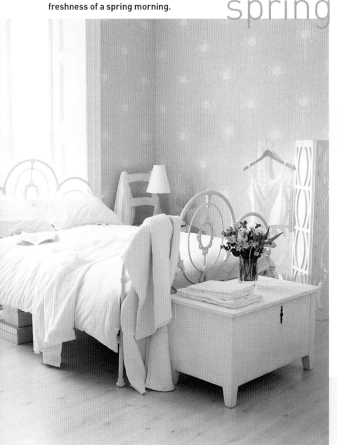

A bedroom should be a special place,
somewhere you are happy to spend
time even when you are not asleep.

colour at home

accent

Try verdant greens tempered by earth tones to bring vitality to your living room. You can experiment with different shades on each section of wall.

woodland

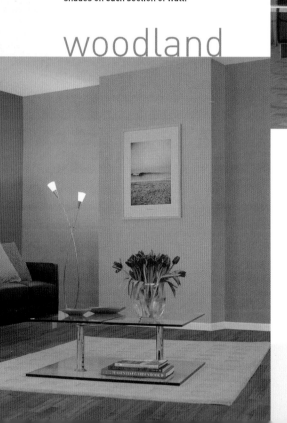

Bright oranges and reds are most effective when used sparingly – here as an accent on a feature wall that is picked up by the colours of the cushions and flowers.

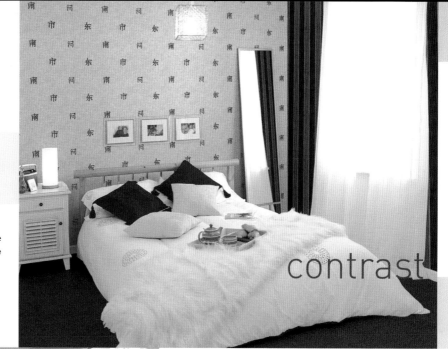

▼ A bold pattern of stripes curving sensuously across the wall makes a stunning feature in this bedroom.

contrast

bold

⚓ White bedlinen against rich dark flooring; striped and patterned wallpapers on neighbouring walls: use contrast in a bedroom to create a confidently stylish mood.

home offices

Wallpaper with a subtle pattern, shelves painted soft green, carpet on the floor: here's a calm, homely scheme for a home office.

calm

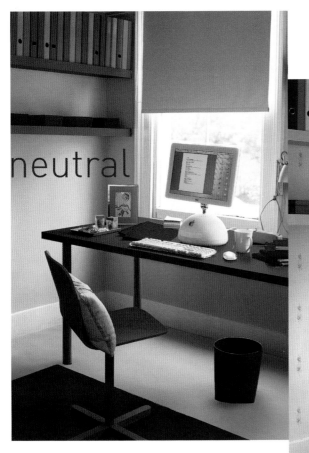

neutral

Bring colour to a neutral theme with accents and accessories. This is a clean, simple and effective look for a small home office.

rosy

A home office is your chance to create a workspace in a style that really works for you.

Dark colours in a small room may be too gloomy, so paint an accent wall only and echo its colour in files, storage boxes, accessories, wastepaper bin and rug.

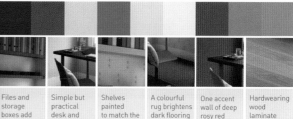

Files and storage boxes add accent colour

Simple but practical desk and chair

Shelves painted to match the wallpaper

A colourful rug brightens dark flooring

One accent wall of deep rosy red

Hardwearing wood laminate floor

Some people need minimalist clarity to concentrate: white, bright and unfussy, with nothing to distract from the task at hand. But bold colour can also be a great way to get the energies flowing when you sit down to work.

Home offices are often small – a converted box room or spare bedroom, for example – so it's important to consider the effects of colour on the space. A scheme based predominantly on white or a cool pale shade will prevent it feeling cramped. If there isn't a whole room to spare, don't overlook other possible spots: the end of a hallway, a landing, or an under-stairs alcove. Use colour and light to zone the space into a dedicated office area.

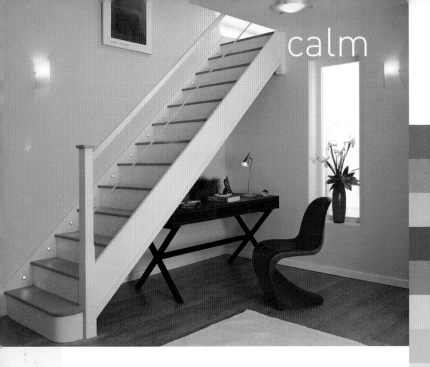

calm

Calm, pale neutrals can be relied on to create a feeling of light and space. You can always add bright touches of colour with accessories, wall hangings and furniture.

Ceiling and wall lights for safety and style

One designer chair makes a real style statement

Wallpaper with subtle pattern breaks up large wall surface

Single wall painted fresh lime green

Deep horizontal bands of colour for dramatic impact

Chair and rug stand out against dark wood flooring

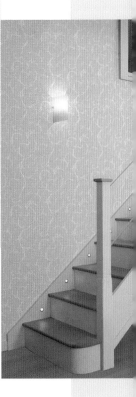

hallways

Once through the front door, your hallway provides a first encounter with the personality of your home.

colour at home

When you want to make an ▶ impression, play with stripes. These deep horizontal bands in shades that match the floor colour are highly dramatic.

inviting

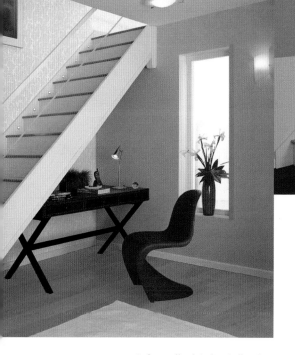

⚓ One wall painted zesty lime is balanced by subtly patterned wallpaper. Green is a calm, welcoming colour – ideal in an entrance and hallway.

The hallway provides a framework for the other rooms that lead off it, so be sure to open all the doors wide before you commit to your scheme, and think about the way its colours will look against those of each room. Natural light may be limited in this area; if so, make the most of what you have with plenty of white or pale tints. Stairs in particular should always be well lit to avoid accidents. Bear in mind that the hallway and stairs are high traffic areas in the home, and they need to stand up to fairly heavy use.

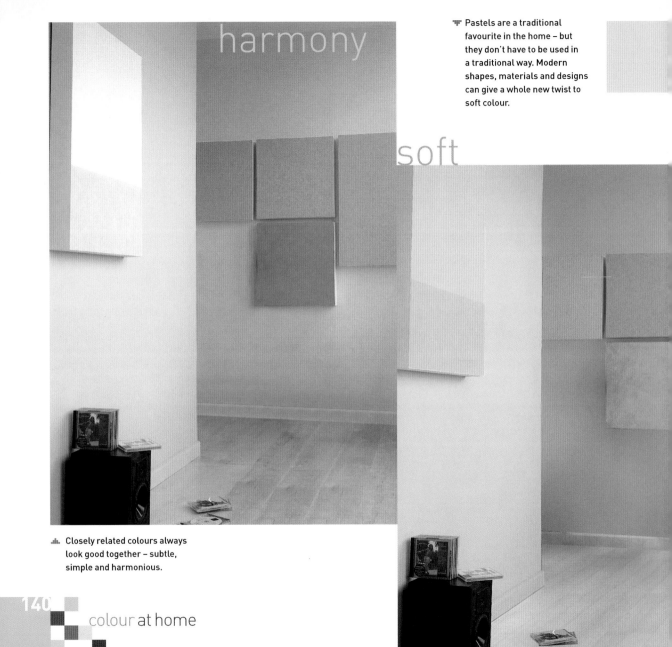

harmony

soft

Pastels are a traditional favourite in the home – but they don't have to be used in a traditional way. Modern shapes, materials and designs can give a whole new twist to soft colour.

Closely related colours always look good together – subtle, simple and harmonious.

colour at home

vivid

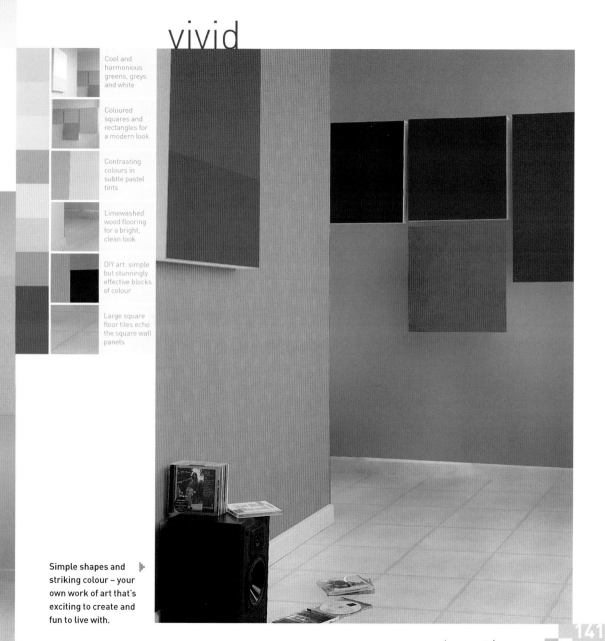

Cool and harmonious greens, greys and white

Coloured squares and rectangles for a modern look

Contrasting colours in subtle pastel tints

Limewashed wood flooring for a bright, clean look

DIY art: simple but stunningly effective blocks of colour

Large square floor tiles echo the square wall panels

Simple shapes and striking colour – your own work of art that's exciting to create and fun to live with.

acknowledgments

p.4 Tom Leighton
p.6 (left) and p.11 (right) © Craig Aurness/CORBIS
p.7 (right) Niall McDiarmid
p.10 © Digital Art/CORBIS
pp.14–15 Gillian Plummer/Flowerphotos.com
p.18 © Red Cover/Steve Dalton
p.23 Anthony Webb (*StyleCity San Francisco*: Thames & Hudson)
p.24 Gavin Hellier/Robert Harding/Getty Images
p.25 (above) © Lindsay Hubberd/CORBIS
p.25 (below) © Raj Patidar/Reuters/CORBIS
p.30 (right) Sue Kennedy/Flowerphotos.com
p.31 (left) Anthony Webb and Ingrid Rasmussen (*StyleCity Barcelona*: Thames & Hudson)
p.33 © Red Cover/Niall McDiarmid
p.34 Niall McDiarmid
p.35 (left, and p.106) Anthony Webb (*StyleCity Amsterdam*: Thames & Hudson)
p.35 (right) © Red Cover/Niall McDiarmid
pp.38–39 Niall McDiarmid
p.42 © Red Cover/Winfried Heinze
pp.44–45 Niall McDiarmid
p.47 Niall McDiarmid
p.49 Niall McDiarmid
p.55 (right) © Red Cover/Graham Atkins-Hughes
p.50 Samantha Scott
p.56 (below) and p.57 Jason Curtis
p.58 Anthony Webb and Ingrid Rasmussen (*StyleCity Barcelona*: Thames & Hudson)
p.59 © Red Cover/Niall McDiarmid
p.62 (left) Anthony Webb and Ingrid Rasmussen (*StyleCity New York*: Thames & Hudson)
p.62 (right) Anthony Webb (*StyleCity San Francisco*: Thames & Hudson)
p.63 (left, and p.106) Anthony Webb and Ingrid Rasmussen (*StyleCity New York*: Thames & Hudson)
pp.64–65 © Red Cover/Simon McBride
p.67 Niall McDiarmid

p.73 (top centre: chair) Anthony Webb (*StyleCity Amsterdam*: Thames & Hudson)
p.73 (top centre: bread basket) Anthony Webb and Ingrid Rasmussen (*StyleCity Paris*: Thames & Hudson)
p.73 (right below: lamp and flowers, plus details on p.72) Niall McDiarmid
p.74 (left with details, plus detail p.73 bottom right) © Red Cover/Wayne Vincent
pp.74–75 (middle) © Red Cover/Brian Harrison
p.75 (right) © Red Cover/Guglielmo Galvin
p.82 (centre: tasselled lamp) Anthony Webb (*StyleCity San Francisco*: Thames & Hudson)
p.83 (top centre: roof tiles) Anthony Webb and Ingrid Rasmussen (*StyleCity Barcelona*: Thames & Hudson)
p.83 (bottom right: shells) Anthony Webb (*StyleCity San Francisco*: Thames & Hudson)
p.84 (plus details p.85) © Red Cover/Niall McDiarmid
p.98 (top left: cushions; centre: starfish) Niall McDiarmid
p.99 (top centre: scarves) Anthony Webb (*StyleCity Amsterdam*: Thames & Hudson)
p.99 (top right: bedroom; centre right: bottles; bottom centre: fireplace) Niall McDiarmid
pp.100–101 Niall McDiarmid
p.106 (centre: breadrolls) as p.35 (left)
p.106 (bottom right: wood) as p.63 (left)
p.107 (centre right: cigars) Anthony Webb (*StyleCity Amsterdam*: Thames & Hudson)
pp.114–15 Niall McDiarmid
pp.116–17 Niall McDiarmid

Additional photography by Kate Barnes and Dan McNally.

The SMARTIES trade mark and image is produced with the kind permission of Société des Produits Nestlé S.A.

Special thanks to International Paints and Graham & Brown for contributing images to this book.

B&Q Instant **Makeover**™ CD-ROM

See the results before you start decorating

This powerful new software, available on CD-ROM from B&Q stores or www.diy.com, enables you to decorate on-screen, either using photographs of your own rooms or sample rooms provided on the CD. There are hundreds of real products to select from, including paints, wallpapers, tiles, floorings, doors, rugs and mirrors. Easy and fun to use, you can create and save as many different schemes as you wish.

Commissioned by David Roth, Marketing
Director, B&Q

B&Q Project Manager Geoff Long
**B&Q Home Improvement Marketing
Manager** Gary Shields

Project Director Nicholas Barnard
Consulting Editor Ken Schept
Writer Maria Costantino
Colour Specialist Professor Clare Johnston
Contributing Stylist Catherine Huckerby
Digital Photo Editing Visualize It Ltd

New photography
Stylist Catherine Woram
Photographer Lucy Pope
Project Coordinator Kate Barnes

Thames & Hudson
Managing Editor Amanda Vinnicombe
Design Manager Aaron Hayden
Jacket Designer Andrew Sanigar
Production Manager Philip Collyer

Designed by Smith and Gilmour

Feedback and further advice
B&Q welcomes your comments on this
book and suggestions for improvements.
Contact us by sending an e-mail to:
thebook@b-and-q.co.uk

First published in the United Kingdom in 2004 by B&Q plc.
This edition published in 2005 by Thames & Hudson Ltd,
181A High Holborn, London WC1V 7QX

www.thamesandhudson.com

Edited, designed and produced by Thames & Hudson Ltd,
London

© 2004 B&Q plc

British Library Cataloguing-in-Publication Data
A catalogue record for this book is available from the
British Library

ISBN-13: 978-0-500-51219-7
ISBN-10: 0-500-51219-1

This book is printed on 150gsm Gardamatt, manufactured
in Italy by Cartiere del Garda in a plant with ISO 14001
environmental accreditation. This paper is produced by
an acid-free process.

Printed and bound in Italy by Canale